DRAW HORSES

HORSES

IN 15 MINUTES

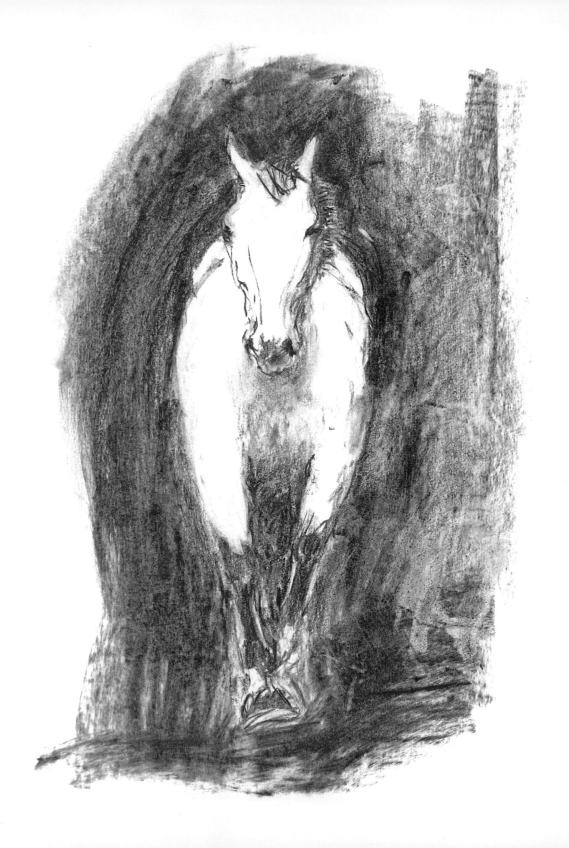

CAPTURE THE BEAUTY OF THE EQUINE FORM

DRAW HORSES

IN 15 MINUTES

DIANA HAND

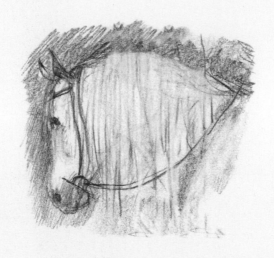

ilex

An Hachette UK Company
www.hachette.co.uk

First published in Great Britain in 2015 by
ILEX, a division of Octopus Publishing Group Ltd
Octopus Publishing Group
Carmelite House
50 Victoria Embankment
London, EC4Y 0DZ
www.octopusbooksusa.com

Distributed in the US by
Hachette Book Group
1290 Avenue of the Americas
4th and 5th Floors
New York, NY 10020

Distributed in Canada by
Canadian Manda Group
664 Annette St.
Toronto, Ontario, Canada M6S 2C8

Executive Publisher: Roly Allen
Editorial Director: Nick Jones
Commissioning Editor: Zara Larcombe
Assistant Editor: Rachel Silverlight
Senior Project Editor: Natalia Price-Cabrera
Senior Specialist Editor: Frank Gallaugher
Art Director: Julie Weir
Designers: Grade Design
Senior Production Manager: Katherine Hockley

ISBN 978-1-78157-249-8

A CIP catalogue record for this book is available from the
British Library

Printed and bound in China

10 9 8 7 6 5 4 3 2 1

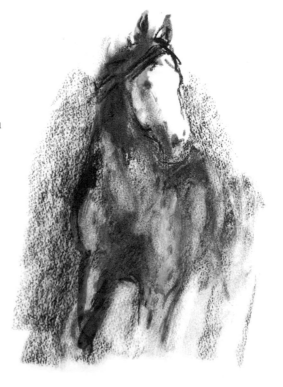

Contents

INTRODUCTION

Drawing Horses

Everyone opening this book shares a love of horses, and a curiosity about how they could express this feeling by making drawings. "Feeling" is the key word here. Horses draw us to their power, playfulness, and gentle nature. They represent an extension of our own capacity in terms of strength and energy, and represent another mode of being—one which we might have lost but which is still deep inside us: an empathy and awareness. Through drawing, we can access that part of ourselves and communicate our feelings about the horse. It is that sense of passion that we want to convey, and which inspires and motivates us in our drawing.

There are as many approaches to drawing horses as there are artists. Learning to draw is a lifelong process of discovery that will take you places you might never have dreamed. As with any new skill you're trying to learn, it can be baffling when you start; but the more you practice, the better you will get, and the more you will enjoy it. This book will give you the skills to build on in order to make any kind of drawing, as well as specialist information about equestrian drawing.

Why Draw?

Drawing is one of the most immediate forms of visual expression and a natural form of communication—we draw lines in the sand, we make everyday sketch notes, we even make simple stick drawings. All it takes is any surface and any mark-making tool. Nowadays, neuroscience is discovering that our bodies make decisions far in advance of our consciousness. Drawing engages the body as well as the eye and the mind, and adds a completely new dimension to our work and our awareness. As you learn to draw horses, you will be constantly surprised at the decisions your body has made in its interpretation.

The Language of Drawing

It is helpful to think of drawing as a kind of language, with its own structure and symbols. Instead of words and sentences, you will use line and tone to interpret what you observe and to express your ideas. This book engages a particular approach to drawing, but you can explore the language in any direction you choose, once you feel confident in the basic skills. The artist never stops learning, experimenting, and revisiting the basics with new understanding.

Beginning

If you are reading this book, you can learn to draw the horse—a notoriously elusive and difficult subject—and to communicate what the horse means to you. You might feel unsure and frustrated at first, but with practice and experimentation, you will find a way of drawing that feels satisfying and natural to you. Learning to draw is rather like learning to ride a horse. At first you feel insecure and self-conscious, but gradually you begin to share in the flowing energy of the horse—just as you will tune into your own joy and playfulness in your drawing.

Draw Horses in 15 Minutes

As you become confident in drawing, and gain experience of how the horse is constructed, how it moves, and how it behaves, you will be able to draw fast and accurately both from life and from memory. Constantly moving between an imaginative, spontaneous approach and close study (observation and theoretical knowledge of anatomy) is important to keep you motivated and to access your own inner energy. This energy is in itself just as much the subject of the drawing as the apparent subject. In your drawing you will be able to express a deep love of the horse in your own unique way.

Why 15 Minutes?

When drawing from life, 15 minutes is enough time for you to get down the basic shapes of your subject. The live horse is likely to be moving, so you will draw only the main lines of its body, legs, and head. Your basic drawing will have life and energy, even if it is not detailed and accurate at first. That life is the most precious quality, so aim to retain that feeling in your drawing while you gradually build more knowledge of proportion, anatomy, and character into it as your observational and drawing skills develop. If you can find a horse that is being held and will stand still for longer than 15 minutes, then take the opportunity to spend longer on your drawing, using the knowledge you find in this book about drawing and equine anatomy.

Make Time to Learn

As with any activity, the more time and energy you can commit, the more progress you will make in drawing. Although the materials, exercises, and skills listed in this book are invaluable, they are of little use unless you practice and experiment with them as often as you can. Your motivation is very important to carry you through. Feel free to use photographs, books, or your imagination as a source of inspiration. When you return to observational drawing, you will find your understanding has changed and deepened. Try using your materials in new and experimental ways.

How to Use this Book

Dip in and out of these chapters as you need to, getting as much hands-on practice as possible. If you are just starting, it is a good idea to focus on earlier chapters before moving on to Chapters 4 and 5.

CHAPTER 2: WHAT YOU NEED
This chapter sets out what materials you will need and suggests ways to use them, both for drawing from life and from photographs.

CHAPTER 3: LEARNING TO DRAW
In this chapter you are guided through the core skills and techniques of drawing any subject.

CHAPTER 4: DRAWING HORSES
The skills explored in Chapter 3 are now applied to drawing the horse, with additional information about anatomy and more advanced drawing skills.

CHAPTER 5: GOING INTO DETAIL
This chapter provides more specific information about different aspects of the horse, such as anatomy, breeds, and movement. Use this chapter for reference as you need to.

WHAT YOU NEED

Your Materials

Chinese artists refer to their paper, ink, and brush as "treasures" or "friends," and this is a useful way to think of your materials. Although your drawing skills may have the greatest impact on the outcome, the quality of your materials will affect both appearance of the work and its longevity. This is important for artists of all levels. It is a good idea to store your drawings carefully and refer back to them often to check your development. You might wish to frame a successful drawing, and it will look much better if you have used good quality paper and drawing materials. For the drawings in this book I used:

- A 2B graphite pencil
- A plastic eraser cut in half
- A good pencil sharpener
- A brush and some water
- Stick charcoal
- Ink
- 120 lb, or 200 gsm, "NOT" off-white drawing paper

The simplest media can make the finest drawings. It is best to start by getting the feel of pencil or charcoal, whether you are making a close observational study or a more expressive drawing. As you develop, you may experiment with other media and different types and colors of paper, and discover how these can change your drawing and lead to new discoveries. Your materials are an integral part of the artwork, and by exploring new ways of using them, you will also find new directions in your drawing. It is important to take care in selecting materials, so here is some basic guidance about commonly used media.

Paper

There are many types of paper in different shades, textures, and weights. Your own choice will be affected by the media you are using and by personal preference. It is false economy to buy cheap paper, even if you are experimenting. Once you have found a paper you like, it's worthwhile ordering in bulk from a specialist supplier.

TYPE OF PAPER

Good-quality drawing papers are acid-free, have good longevity, and are resistant to discoloration. Look for smooth (known as "HP") or slightly textured ("NOT") paper if you are working in pencil or charcoal, unless you want a grainy look or want to use water, in which case buy watercolor paper. Construction paper is attractive for quick sketches, but the drawings will not last. Similarly, newsprint or lining paper, although cheap and useful for experimenting, will deteriorate and turn yellow in time.

COLOR OF PAPER

An off-white paper is a more sympathetic surface to work on when you are using pencil or charcoal, but a mid-tone paper will give a softer effect, so it is worth trying out different shades, including colored papers. Test colored papers for fastness by leaving sample pieces in the light for several days.

WEIGHT OF PAPER

Weight of paper is measured in pounds per ream (lb) or in grams per square meter (gsm). Papers between 65–120 lb (100–200 gsm) are suitable for drawing, although heavier papers are preferable for water-based work. Drawing is a direct, physical experience, and the feel and weight of the paper are an important part of this, so try out different weights, including feather-light Japanese and Chinese papers for working in ink and wash.

DRAWING BOARDS, EASELS, AND SKETCHBOOKS

Use a drawing board to support your paper, with clips or tape to secure the sheets. A pocket sketchbook for quick sketches and a portable easel and stool for outdoor work are useful extras. A roll-up drawing case is helpful for instant access to pencils, erasers, and sharpeners.

Graphite

PENCILS

Graphite (lead) pencils are a low-tech and highly versatile tool: small, light, and portable, and capable of a wide range of marks and tones for drawing. Pencil marks can be easily erased, which makes them an ideal medium for the beginner. Water-soluble pencils are available to use as normal lead pencils, but with the option of creating tone and softening line by the use of a brush and water. Pencils are available in 19 grades, ranging from 9H (hard and light) through HB to 9B (soft and dark). The most useful grades for sketching and general drawing are HB to 6B.

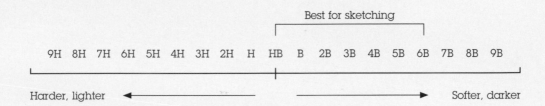

Best for sketching

9H 8H 7H 6H 5H 4H 3H 2H H HB B 2B 3B 4B 5B 6B 7B 8B 9B

Harder, lighter ← → Softer, darker

SHARPENING

Keep your pencils sharp by using a good-quality sharperner (one with a reservoir for the shavings is useful) or a blade. For a wider or softer line sand down one side of the pencil lead. Store your pencils in a box or roll-up brush case.

Erasers and Paper Stumps

Erasers vary in composition and effectiveness. They can also be excellent drawing tools. The putty eraser is available in hard, medium, or soft grades, and can be kneaded into different shapes as required to highlight small or larger areas of charcoal. Paper stumps are shaped like pencils, but have no lead, and are used to soften areas of tone.

Plastic or vinyl erasers are more suitable for pencil work. They can be trimmed to a point for use as a drawing tool.

Charcoal

Charcoal is a black, painterly medium that allows for a range of soft and expressive marks. It is easily smudged or drawn into with a putty eraser, and is particularly suitable if you want to work quickly and spontaneously. Spray fixative is needed to hold the completed drawing.

WILLOW

Willow charcoal comes in various shapes and thicknesses. It is fragile and dusty but makes powerful velvety marks on the paper, which can easily be erased. Use it on its side to create broad sweeps, or use the point to make fine lines. Crushed charcoal can be applied as powder. Remove excess dust from your charcoal drawings before fixing.

COMPRESSED

Compressed charcoal is charcoal dust mixed with a binder, and it comes in the form of rectangular sticks. It gives a more intense black than willow charcoal and is harder to erase because of the binder content. It is also available in pencil form in various grades from light to dark.

Fixatives

Spray fixatives are available in aerosol form and should be used to fix pencil and charcoal drawings to avoid damage during framing or storage. Apply horizontally in two light coats to avoid soaking the drawing. Hairspray makes a cheap alternative when you're starting out.

Pen and Ink

Ink makes a permanent mark that cannot be erased. A liquid medium, it has a flowing quality different to pencil and charcoal, and it can be applied with a pen, brush, or stick for different effects. Start with black ink, and use good-quality ink such as India black ink. This can be diluted with water in a separate jar and applied with a brush to give degrees of tone.

You can buy special art pens and high-quality inks, but just to explore its effects there is a huge range of cheaper pens available, from the ballpoint to the fine-liner. There is a special pleasure in drawing in line with ink, so it is worth going for a better quality to avoid frustration.

Setting Up to Draw

Pick Your Kit

Horses live in stables and pastures away from our domestic environment. You will need to be prepared for variations in weather and location, and also be aware that you are drawing highly sensitive animals that can panic at the sudden sight of a sheet of paper, especially if it flies across their path. Keep your tools in a closed bag and your drawing materials in a roll-up fabric container.

Once you have found your subject, decide what materials to use. Make sure that your paper and board are of suitable size. Too large might be unwieldy if you are sitting at a paddock gate. Check that your paper is securely fastened to the drawing board, your pencils are sharpened, and your erasers ready. Have some fixative to hand so that your drawings do not smudge. A good starting kit is:

- HB, 2B, and 5B graphite pencils
- A sharpener and pencil eraser
- Paper fixed to drawing board
- Spray fixative

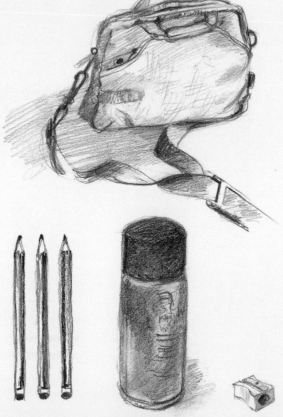

Horses as Models

Drawing subjects like horses can be frustrating at first. They are always moving and shifting their weight, even when standing or grazing. Rarely are they still long enough for you to make a close detailed study from life, unless you can persuade someone to hold a patient horse for you. This is known as a "held pose" and is a great opportunity to study the structure of the horse as a whole, or just individual parts, such as the head or the legs, that interest you.

The more you practice and observe, the more you will be able to draw from your knowledge and memory and fill in the gaps when the horse changes position. One approach to learning is to make quick sketches, translating shapes into line and tone on your paper. Remember—it is the movement of the horse that makes it such a fascinating subject.

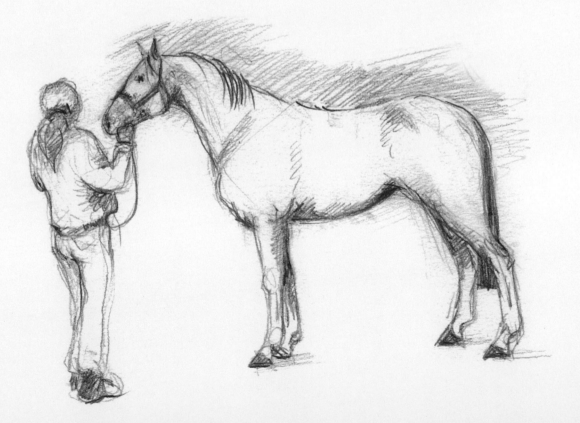

Drawing from Life

Where to Find Horses

It can be difficult to access real horses to draw, especially
if you live in the city, but you will find horses everywhere
if you look hard enough. Police horses patrol the streets,
horse-drawn cabs carry tourists around the sights. Look for
riding schools and ask permission to go and sketch. Many
cities have a racecourse—go for the day and draw the
action. It is important to draw live horses at first hand if
you seriously want to learn to draw them well.

Outside of the city you might find pleasure horses,
or working horses used for ranching or patrol work. Seek
out local horse shows and agricultural shows—especially
if you like to draw the old-fashioned heavy draft horses.
Keen riders hold clinics to learn more about jumping,
dressage, and even gymnastic vaulting on horses; for
a small fee you can attend these clinics as a spectator.

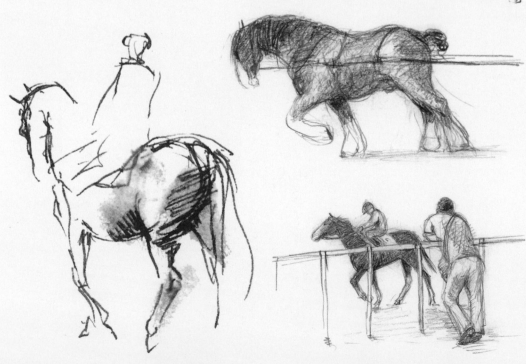

Drawing "In the Field"

Take your basic kit and commit time to drawing, making quick sketches or more developed drawings as you wish, or circumstances allow. Try to move around and draw from different angles. The horse is a complicated shape, and much of its fascination lies in the contrast between its beautiful head and long, slender legs and its bulky body. Don't worry too much about results; just keep looking and drawing. You will often be pleasantly surprised when you look at your work over the next days or weeks.

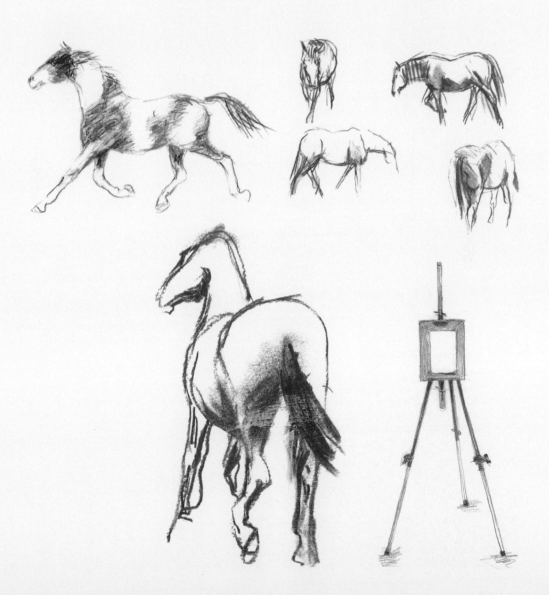

Drawing from Photos

A photograph cannot replace drawing from life, but it can be a reference to support it.

The camera intervenes between your eye and the subject to capture one moment, but it cannot replicate the depth and sensitivity of your vision and your interaction with the live subject. However, it provides access to a vast range of images that can extend your repertoire and understanding of your subject, and, if you have never drawn a horse before, making simple copies from photographs can be a good place to start.

Your Own Photographs

When working from life, you might take snapshots to back up the session. The advantage of this is that you get to choose the detail that is personal and relevant to you, and later in the studio these photos can be used alongside your quick sketches to create new drawings, or to work from memory. Your own vision is selective. You may be focusing on the horses in the foreground but miss the stable, yard, or paddock that gives the subject context—and which the camera will faithfully record.

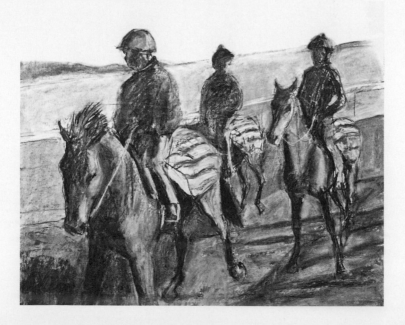

Other Media

The horse is a favorite subject for artists and photographers. Use the internet to find work that inspires you to explore new approaches to your work, and also look for specialist areas such as horseracing for high-quality action photographs of horses running and jumping. Create a folder of work that interests you, and refer back to it as you need to.

Print media such as newspapers, magazines, and books are also good sources of information and inspiration.

Setup

When drawing from another source, whether your own drawing, a photograph, or an image on the computer, make sure that you are working on a similar plane to the source. Using an angled drawing board will make it more comfortable to work and also help you to avoid distortion. You can improvise by propping your board up on books or bricks.

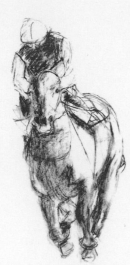

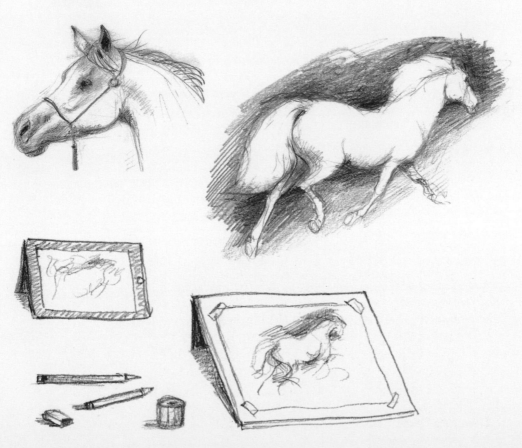

LEARNING TO DRAW

Attitudes and Techniques

Attitudes

Every artist is different. Some people need to work in a precise way; others work directly from instinct to express their excitement and engagement with their subject. If you insist on very careful procedure, you might never find your freer creative self—and if you never stop to analyze, you might sometimes achieve attractive and spontaneous drawings, but you will probably become frustrated by a lack of knowledge and by the inconsistency of your work, and find it hard to progress. The truth is that we need to learn to use both approaches when we learn to draw, and to move in a continuous cycle between expression and exploration.

It is important to be aware of your intention when you begin a drawing. It's easy to become overwhelmed by the complexity of the subject, and your drawing may lack impact as a result. Decide what interests you about the horse you are drawing. Are you drawn to the overall shape of the animal or the expression on its face? Do you want to show movement, or the horse relaxed in stable or pasture? Do you want to emphasize the breed of the horse and how this affects its proportions and size?

Start by selecting a particular aspect and an appropriate technique, and focus on that. This will create a framework and discipline that will allow your work to flow and find its own life.

Techniques

This book suggests basic techniques that will help you to look and translate your perception into drawings. You will gain a firm foundation in drawing, but, as with any skill, it is necessary to constantly practice and explore if you want to go further and find your own form of expression. Drawing is a two-way process, and you will find that your subject will inform you in a kind of dialog. Be open to this; make several drawings of the same subject with different materials and from different viewpoints, and allow your

work to move in unexpected directions and toward greater simplicity. The more you immerse yourself in drawing, the more this will happen, and the more you will appreciate and learn from the work of other artists, and find satisfaction in your own work.

Style

Your drawing style is your fingerprint, your artistic DNA, and is very difficult to change. It will look after itself as you focus on observing your subject and expressing your fascination with it. As the famous equestrian artist Edgar Degas (1834–1917) once remarked, "I'm glad to say I haven't found my style yet. I'd be bored to death." If you enjoy drawing in a certain way, particularly in your imaginative work, then by all means do that—but continue to experiment and explore style and technique more deeply. Never rest on your achievements. There is always so much more to learn.

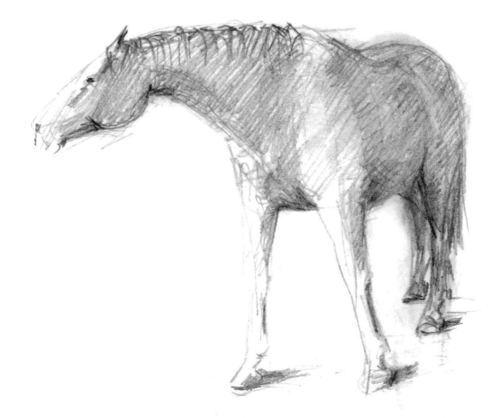

Looking

Learn to Stare

At times you might want to work quickly and spontaneously, particularly when doing sketches or drawing from memory, but when making studies from life, it is best to spend some time looking at the subject before you start drawing. Your mind will try to draw what it already knows, but the joy of drawing is learning to see afresh and understanding your subject ever more deeply.

Look as though seeing your subject for the first time, and make each line and mark the result of a conscious decision and observation. This may feel laborious, but trust your inner artist to transform your work into a strong and personal statement.

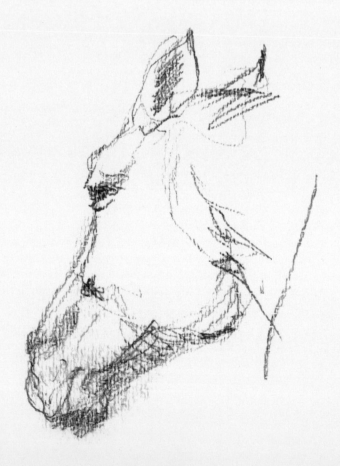

Develop an Internal Tutor

It is the process of quietening your mind and really focusing on your subject that will combat the internal self-imposed critic that many of us have when beginning any new skill, and in particular an artistic skill. Drawing is a natural and playful form of expression for humans, but during our early life it very often takes second place to academic and practical achievement, and we become convinced that we "can't draw." An inner critic will then overwhelm our efforts with negative feedback, and make us feel despairing about the gap between our vision and our work. On top of this, art is a personal and subjective adventure that sometimes accesses deep emotions. These can also emerge and be painful to endure.

This book will describe the process of drawing and give you a basis for assessing your own work. Every now and then, take a break from the work, and step back to look at it objectively. Are the proportions and tonal balance right? What do you like or dislike? How would you do it again differently? Learn to be your own internal tutor and have confidence in your own judgement and unique achievement.

Remember that every artist, from the beginner to the most successful and experienced, feels that they could do better. Don't be frightened of failure. Try again and learn from your mistakes. You will find they will melt away—to be replaced by new challenges. Look at the work of other artists, but do not compare your work with anyone else's; it is uniquely yours, and your development is yours only.

Set Aside a Time and Place

If possible, have a special area for drawing and make a commitment to spend time there as often as you can. At the beginning of a session you may feel reluctant and unable to access your creativity, but you will often be surprised how this will change once you start work. This practice time is important for any artist. Think of it as a kind of meditation that will reveal many surprises.

23

Core Skills of Drawing

Drawing is a skill requiring coordination of mind and body, just like learning to drive a car or ride a horse. It is useful to be aware of the core perceptual skills of drawing, and focus on one at a time until you can integrate these skills effortlessly. If you are just beginning, you may want to skip ahead and start drawing horses straight away with Chapter 4, returning to this chapter when you have more experience. If you are an improver, read this chapter now.

Before describing the core skills, it is worth mentioning that when we draw we normally use three sources of imagery.

Observation: Directly looking at a subject, either from life or from secondary material.

Memory: Drawing from something you have seen and remembered, consciously or unconsciously.

Imagination: Inventing new ways of looking at the world or extending what you already know.

The three sources are not separate; they overlap when we draw. Even when you feel like you are drawing purely from observation, you will be using memory as you look from subject to page, or interpreting your perception via previous images you have seen or drawn. You will use your imagination in the way you emphasize aspects of the drawing and place it on the page, and in the way you think about it. Drawing from memory and imagination has a pleasure and freshness about it that is harder to achieve from observational studies. It is closer to your personal statement. However, you still need to observe to expand your knowledge of the subject and your own drawing ability. Observation is the heart of drawing.

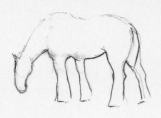

Core Perceptual Skills

Seeing edges: Seeing outlines and boundaries. Often expressed in linear drawing.

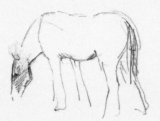

Seeing negative spaces: Seeing the spaces around, between parts of, and within the subject. Can be expressed in tone or line.

Seeing proportion and relationships: Understanding how one part of the horse relates to another. This includes proportion of each part in relation to each other, and also perspective and foreshortening (see page 78).

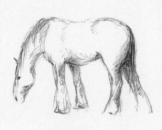

Seeing tone: Seeing the subject in terms of light and dark, ranging from darkest to lightest parts.

Seeing the whole: Seeing the subject as a whole, using the core skills selectively and unconsciously, in combination with memory and imagination, to create the artwork.

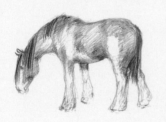

Beginners often achieve very strong results without knowing how. With practice and a growing knowlege of these skills, you will become more aware of how you are building your work to achieve the outcome you want.

The core skills form the basis for the tutorials that come later in the book. The more you practice drawing, the more sense they will make to you.

Mark-Making

Mark-making is the physical act of drawing, and all the image sources and core skills come together when we actually apply pencil to paper. Drawing is much more than a two-dimensional technical rendition of a subject. It is a trace on paper of your own unique mind, body, and emotions, and can be a powerful tool of expression. Some artists consider the mark to be a work of art in itself; others build it into a more precise approach to drawing. You will find your own way.

Observational Measuring

Observation is at the heart of drawing. It is an important skill to be able to depict your subject accurately, even if later you decide to exaggerate or distort it for expressive or imaginative reasons. The more you draw and look carefully, the more easily you will be able to depict your subject accurately. It can be difficult to visually assess your subject's proportions, though. Your brain constantly intervenes with memories and preconceptions, and overrules what your eyes are telling you. Learning to "see" requires constant practice, and artists use special observational methods to help them.

Measuring with a Pencil

Hold your pencil vertically at arm's length, close one eye (to flatten what you see), and place the top of the pencil at the edge of one thing you want to measure. Slide your thumb down the pencil to give a measurement. You can then compare this to other parts of the subject to check relationships and proportions.

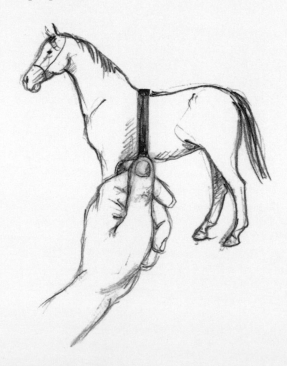

Verticals, Horizontals, and Diagonals

Another useful way to check your drawing is to hold your pencil vertically, as described for measuring with a pencil, and align it to a part of the subject—for example the withers of the horse. Run your eye down the pencil and check the position of the front legs in relation to this. Check this with your drawing. By holding the pencil horizontally you can check the relationship between the withers and the top point of the hindquarters, and so on. Diagonal comparisons can be made in the same way.

Viewfinders

It is easy to be overwhelmed with visual information. An effective tool to help you focus on your subject is a simple viewfinder. Cut a rectangle or square out of a piece of card and hold it up to get a clearer view of the subject. This will help you see shapes, lines, and tones in a fresh and sometimes unexpected way.

Visual Language

Visual thinking is a basic form of human communication. Writing and numerals are highly symbolic forms of mark-making, but sometimes a drawing made using the simplest marks can convey a subject effectively and directly. Early cave drawings made thousands of years ago are still highly effective depictions of animals, and these drawings were made only with earth pigments and with a few lines using charred sticks. How much less impact they would have if described in words, and how much their simplicity adds to the drawing.

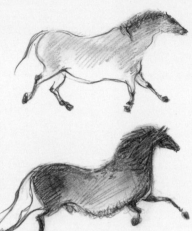

Written vs. Visual Description

Words can be extremely clumsy in describing an object, in comparison to the directness of a drawn image. Here's an example, describing the difference between two cups:

"The first cup is a simple cylinder of sturdy china with a D-shaped handle. The second cup has a curved shape narrowing into a base around two-thirds in diameter from the body of the mug. The handle is S-shaped, and the mug has a lid that overlaps slightly and which has a small knob on it. Mug and lid are decorated with a pattern of peony flowers, with a formal border at the rims."

Here's a drawing that provides the same information:

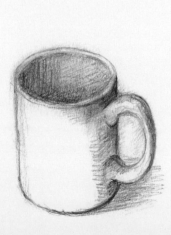
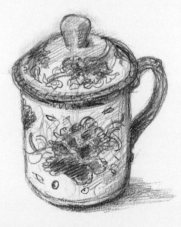

Purpose of a Drawing

Often, a few carefully observed marks will be more effective than a photo-realistic drawing that contains every detail. The more you draw, the more you will find the kind of tools and mark-making you enjoy, and the approach that is best for you.

Before you start to draw, think about what interests you in the subject and what you want to say about it. Focus on your decision and use the simplest visual vocabulary you can.

Try numerous drawings of the same subject using different core skills; concentrating just on line or on tone, for example. You will find your drawings become freer and more spontaneous as you connect to your subject.

The three drawings of a horse below tell different stories:

1) Shape and pose
2) Light and form
3) Attitude and character

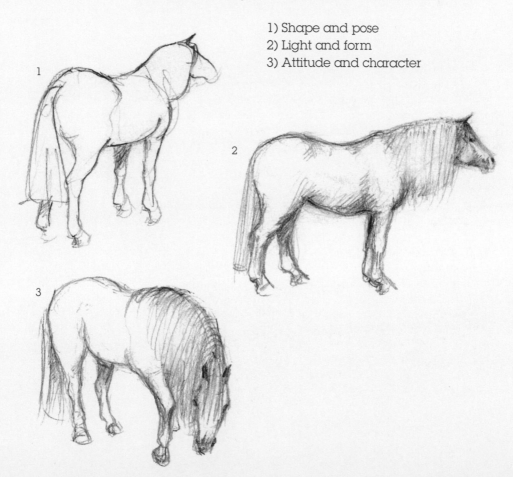

Making Marks

Becoming Aware

Experiment with the way you use your arm and hand to draw. You may start by resting your hand on the paper and holding the pencil or charcoal between thumb and forefinger as though you were writing. Then loosen your wrist to make freer marks. Make sure your paper is secure on a board and draw from the elbow or shoulder. You will be surprised at the strength and energy in your marks.

Drawing using thumb and forefinger for maximum control and precision

Longer curved marks drawn from the wrist

Free, loose marks drawn from the elbow

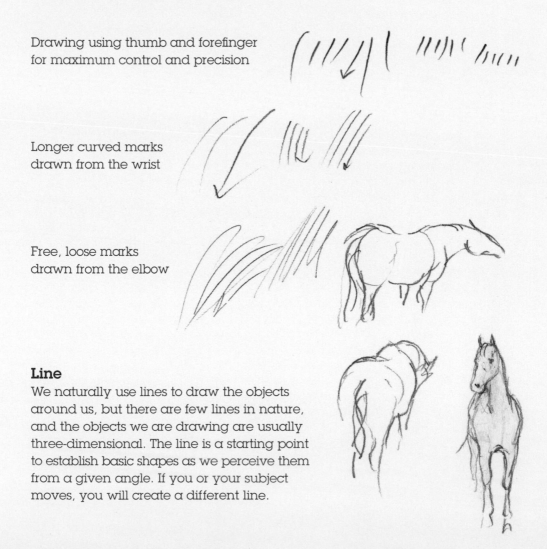

Line

We naturally use lines to draw the objects around us, but there are few lines in nature, and the objects we are drawing are usually three-dimensional. The line is a starting point to establish basic shapes as we perceive them from a given angle. If you or your subject moves, you will create a different line.

Drawing a Line

A drawn line can have many different qualities. It can be soft and delicate, strong and expressive, light and precise, flowing or straight, thick or thin, or any combination of these at once. There are as many lines as there are artists, and your line will be affected by your materials and how you use them—whether you're using the point of a sharp pencil or the side of a blunt one, for example—as well as the surface that you are working on.

You may feel self-conscious when you start to draw, and a beginner's line is often hesitant. Focus on looking at the shape of your subject and deciding where you want your line to start and stop, then draw the shape in one continuous movement. The key is in the looking, and your hand will translate this into a lively line. If you are not satisfied with the result, then erase and redraw with increased knowledge and confidence.

Beginner's line

Sharp pencil

Blunt pencil

Weight of a Line

A medium-grade pencil (such as a 2B) is ideal for controlling pressure in order to create different weights of line. It can create a range of lines from the lightest gray to a strong gray/black, and the width can be varied by changing the angle of the pencil; angling it low and close to the paper will give a broader line, for example. Varying line weight helps to show shadow and form, and gives vitality to your drawing.

Tone

What Is Tone?

Tone, also known as "value," means the light and dark in a drawing, and describes how the light falls on the subject. Colors have their own tone, which will also be affected by the quality of the light.

When you are drawing tone, the best way to work with color is to think of your subject in grayscale. Your phone or camera will readily convert an image to grayscale, and you may be surprised at the tonal value of the colors. You can also half-close your eyes to assess the tone in a subject.

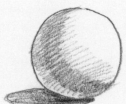

Why Is Tone Helpful in a Drawing?

Tone is helpful because it gives a fuller description of the subject than a line drawing. Imagine a flat, linear drawing of a horse. This can be effective, but if you are interested in the shapes of the horse (its muscles and bones and its big round torso) you can use tone to explore and describe this aspect. Similarly, you might want to say something about the coat color and the markings of the horse.

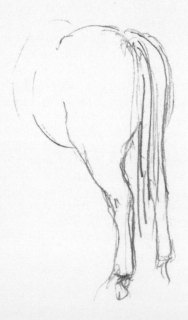
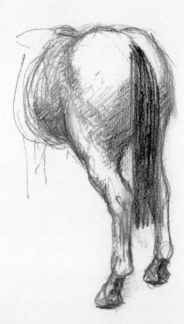

Tonal Range

Tonal range extends from pure black to the lightest white, with shades of gray in between.

Unless you are working on tinted paper, the lightest tone is the paper itself. Do not feel you have to include the full range of tones in your drawing. You can use a range of light tones, or just work from the darker end of the range. Pencil grades vary in their range of tone. The H/HB grades make delicate tonal marks, but 2B–6B are softer and will produce a deep velvety black.

Experiment with using the tip and side of a pencil.

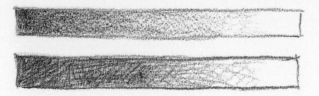

Using different grades of pencil will create a varying range of tones.

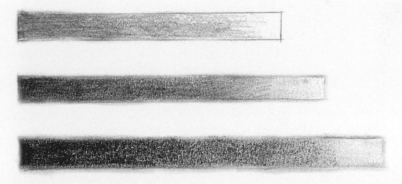

Try working with different grades of pencil to achieve a good range of subtlety and depth in your drawing.

Making Your Mark

How do you create tone with your pencil? The tried
and tested approach is to either use short parallel lines or
cross-hatched lines. Use curved parallel lines as directional
shading to follow contours of the horse's body, and vary
the direction to give vitality. You can also experiment with
smudging the lines with your finger or making a soft area
of tone with the side of your pencil. Keep your cross-hatching
as diamond shapes, as this works better in describing tone
than a grid. Avoid random scribbling—this is better for
describing texture.

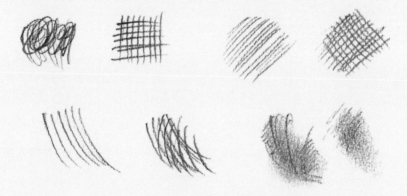

The tonal structure will be very important to your drawing.
Often, it might be what unconsciously attracted you to the
subject. Spend a while looking, and be aware of the
different tones in your subject before you start drawing.
Make sure to keep the mid-tones distinct from each other
as well as from the darkest and lightest areas. This will
get easier with practice.

Tone is important in composition as well, and you
will have the chance to explore that in later exercises.

Practice shading your range of tones.

Pencil Holds

Hold your pencil in different ways to achieve different kinds of marks.

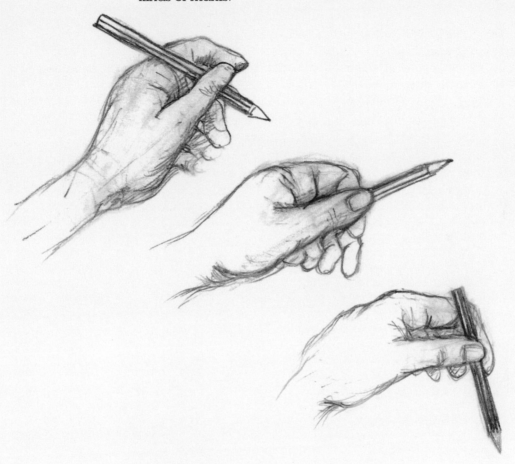

Eraser Work

Use tone freely. If you stray outside your boundary lines with your shading, you can leave this in to give energy to the drawing, or you can clean it with an eraser. You can also lighten areas of tones with the eraser.

Light and Shadow

Tone and Shadows

Once you're confident in handling tone, you can use it to create a three-dimensional effect (or "form") in your drawing by drawing the shadows. It is useful to know how shadow indicates form, because this will give your drawing strength and understanding. Shadows are created when the light falling on the object is blocked—not just by outside sources, remember, but also by an uneven surface, such as anatomical detail.

Keep the blank white of the paper as the very lightest tone. If you're using tinted paper, then use white or light-colored chalk to create highlights. Look at shiny objects (including the horse's eye) and see how bright they are. Increase contrast between areas of dark and light by using your eraser to lighten the tone. Strengthening the line of the parts of the subject that are nearest to you and allowing more distant parts to recede will help create a convincing three-dimensional form.

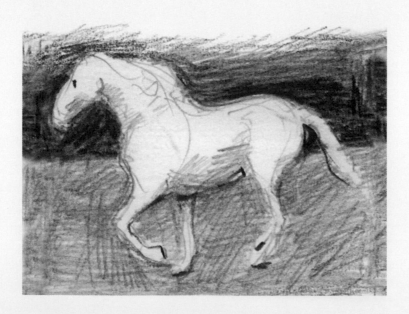

Tonal Drawing

Be prepared to tweak your drawing a little by simplifying the tonal range and exaggerating the darks and lights. Keep it simple at first. Try drawing with just four values: one very dark, one lightest, and two mid-values. Unless you are looking for an extremely pale or a dark and contrasted drawing, then you should include a full range of tone (from darkest to lightest), even if the darkest is just a touch, and the lightest a highlight in an eye.

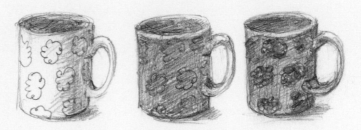

Tone and Color

Most objects are colored, and it can be difficult to see the true tonal pattern in your subject because colors have their own built-in tones, and your brain will want you to draw that. Yellow is usually lighter than brown, for example, but this can vary with the particular shade, and with the amount of light falling on the color. Try to ignore what you know of color and instead translate the subject into tone, using the grayscale technique (see page 32) or by squinting your eyes. This will become easier with practice.

Insider Knowledge

Look at the subject and decide where the light is falling and how it is creating shadow. Draw in the tone, and use the eraser to increase contrast between light and dark areas. Add an area of tone in the background to bring the drawing forward.

Life Studies vs. Photographs

With a subject like horses, the use of photographs as reference is crucial. Around 130 years ago, Eadweard Muybridge's photography first showed how the horse actually moved at rapid gaits (for more about this, see the section on gaits in Chapter 5). Photography can widen your viewpoint and extend your knowledge in many other ways, but it goes hand in hand with observational study. Drawing from life in all its challenging three-dimensional reality provides a depth and immediacy that will add quality to your work.

Sketching and Drawing from Life

PROS

- The immediacy and presence of the horse will inspire you.
- The opportunity to move around the subject and see it from different angles.
- You will quickly learn to be flexible and adaptable.
- As you learn to really look, you will constantly be surprised at your assumptions.
- The interaction with the horse—they will love the attention, which is so different from the usual demands made on them. Horses like just to hang out.

CONS

- It can be difficult to get a sustained study, as animals move around.
- It requires time and effort to find models.
- Drawing from life can be frustrating until you become more experienced.

Sketching and Drawing from Photographs

PROS

- A photograph can help you to develop an understanding of anatomy and conformation.
- There is more time to work on your drawing and practice your skills.
- You can use your own photographs as backups for sketching from life to get the best of both worlds.

CONS

- You are limited to one viewpoint.
- The camera lens may distort perspective.
- A photo is flat, lacking the subtle three-dimensionality of working from life.
- You may be tempted to reproduce the photo exactly, rather than using it as a jumping-off point.

Sketching and Drawing from Memory and Imagination

One of your most important sources of material is in your own head. If you are a horse lover, it is possible that as a child you drew horses from your imagination. That ability is still in you. You might have your own horse or work with horses, and have close knowledge of them and their ways. If you admire horses for their beauty and strength, that admiration can be a source of inspiration in itself. Think "horse" and you will probably find that a scene immediately leaps to life inside your mind. I suggest just drawing and seeing what happens. You can then use your life studies and photographs to check and develop your ideas.

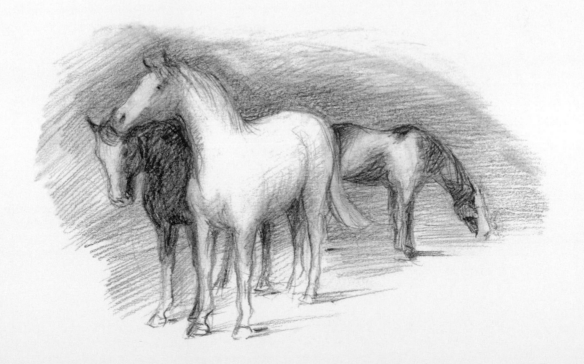

DRAWING HORSES

Beginning and Improving

There are three stages in making a drawing: establish, construct, and elaborate. First, you need to establish your overall impression in order to say what attracted you to the subject. This quick sketch should hold an energy that is the basis of the drawing. Use it as a foundation on which to construct and develop the shapes and forms of the subject. Once you are happy with these two stages, you can elaborate on the drawing by working on the surface details and making the finishing touches. Partially erase your work between each stage so that you can add revisions and additions as you proceed.

This chapter will take you through these stages step by step, with exercises to help develop your skills along the way. By the end you will be able to draw a horse in 15 minutes. This approach to drawing can be applied to any subject. It is a way of retaining freshness and spontaneity, while also exploring your subject in depth.

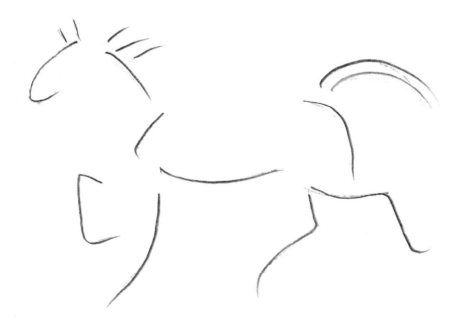

A Beginner's Approach

If you haven't drawn for a long time, you might find the first stage of establishing the shape challenging. Try to remember that you are expressing what excites you about the subject—don't worry too much about accuracy—and remember that you are going to erase a lot of your drawing before you move on. You can start with the construction stage if you find it easier, but, as you gain experience and confidence, return to these early instructions to see if they have more meaning to you.

Improving and Advancing

If you are already a confident draftsman, you will be aware of how much there is to learn and how valuable it is to revisit basic aspects such as tone and line. Learning to draw is a life-long process and a limitless journey of discovery, full of revelations as your hand, mind, media, and subject interact in unexpected ways. The method used in this book may be new to you, so experiment with it and try the exercises in this chapter. The final section of the book will give you more specific information about drawing horses.

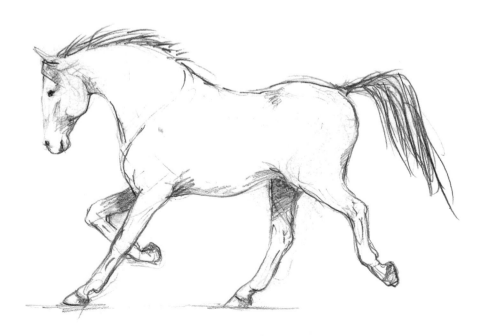

Stage 1: Establish the Pose

What is an "Establishing" Sketch?

The establishing sketch is a fast, gestural drawing made in response to your first impressions of your subject. At this stage, you are firstly breaking the white of the paper, as well as laying out the basic shapes that will later be developed into a more solid form. Try looking at the subject more than at the paper, and work swiftly to capture the whole impression. You might find it helpful at this stage to use a softer-grade pencil, such as a 2B or 4B, or a stick of charcoal, to make broad and loose marks quickly; also try to think of this first drawing as a form of play. Before you begin, warm up by signing your name or doodling on a scrap piece of paper, and then work with a relaxed shoulder and arm. Don't worry if your drawing looks unlike anything you have ever done before, or even if it doesn't look much like the subject. You are going to erase most of it, and the important thing is to make a start and set the scale. You might find that you have produced a strong gestural drawing that is already a finished work in itself.

What Skills Does It Use?

You are using the skill of "looking"; in particular the core skills of seeing edges, shapes, and relationships to focus on the whole animal and on what especially interests you.

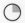 **10 seconds–1 minute**

Mark-Making

Use long sweeping marks made from the wrist or elbow, and use a soft medium or water-based materials.

How to Improve

Practice making quick, incomplete sketches from life at every opportunity.

A: GESTURAL SKETCH

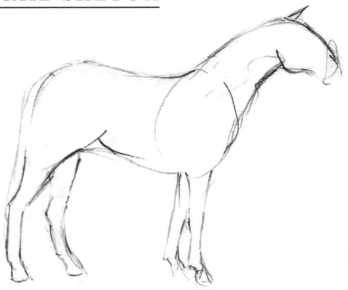

B: ERASE

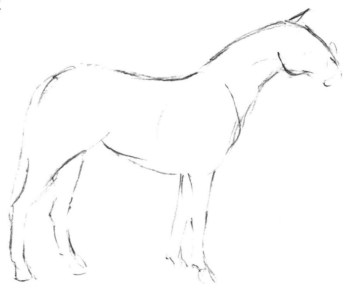

Stage 2: Construct

What is a "Construction" Drawing?
In the construction stage, you will be taking a more analytic approach by exploring the underlying structure of the horse. But to start with, just draw some large loose shapes that approximate to the main internal shapes of the animal. Don't worry about complex details; just roughly sketch the shapes you see. This stage will build on the holistic approach of your first drawing, and is surprisingly effective in setting down an accurate overall impression. Once you have captured the main shapes, link them together with loose flowing lines.

What Skills Does It Use?
- A basic knowledge of anatomy can be very helpful at this stage.
- The core skills of seeing shapes and the relationships between them are implemented in a construction drawing.

🕐 3–5 minutes

Mark-Making
Work with a relaxed arm and allow your hand to make loose shapes and flowing lines. A softer medium, such as a 2B or 4B pencil or charcoal, is useful.

How to Improve
Study basic equine anatomy, and practice seeing shapes in both living and inanimate subjects.

CONSTRUCT

A: BASIC INTERNAL SHAPES

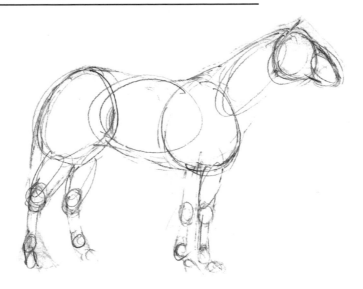

B: FLOWS BETWEEN SHAPES

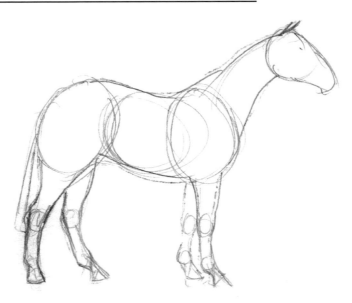

Parallel Stage: Anatomy

What Is the "Parallel" Stage?

This stage is more about understanding than about drawing. It is a good idea to take some time to get to know the main bones and muscles of the horse. More information will also be given in the final section of this book, "Going into Detail." The underlying anatomy of the horse is very evident on the surface of its body, for example in its head and legs.

When you drew the basic shapes in the construction drawing, you were drawing the main anatomical parts of the horse—its head, forequarters, torso, hindquarters, and legs. All horses have the same basic anatomy, although they vary widely in size, length of leg, and musculature, according to breed and the individual. A knowledge of anatomy also helps you to understand the proportions and movement of the animal, and of course helps you to understand your horse better.

How Much Do You Need to Know?

You are making an artwork, not an anatomical study, so don't feel you have to learn the names of bones and muscles and draw them precisely. To start with, it is enough to be aware of the main bone structure and some of the most important muscles. The more you draw horses, the more you will appreciate their anatomy and how strongly it affects their movement and appearance. If you draw from memory and imagination then you will need a good anatomical knowledge (because you have no model in front of you).

Biological Anatomy and "Stick" Anatomy

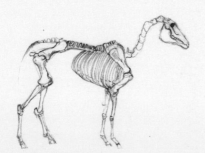
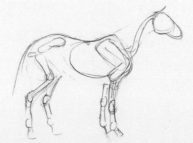

Think about: skeleton

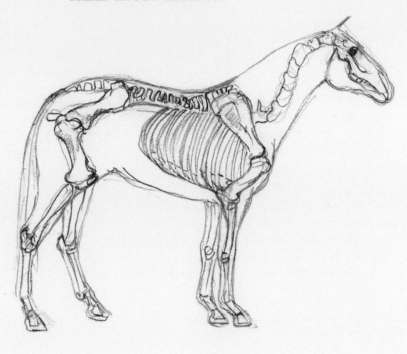

Think about: muscles

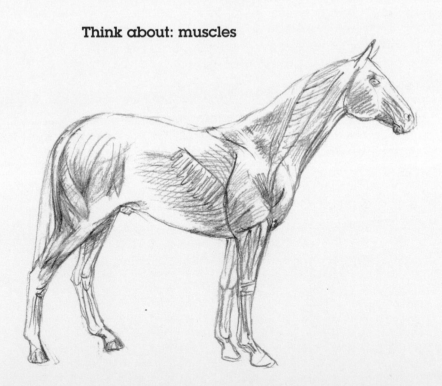

Negative Spaces

What Is Negative Space?

Switching your focus away from the subject to the
shapes around it is a great way of ensuring that you
are really looking, and not just drawing what you think
you see. In this context, negative spaces are the shapes
around the horse that are not part of its body—such as
the spaces between its limbs, or between the horse and
its environment. If you have difficulty working out how
the horse's head, neck, and shoulders relate, or how its
front legs are placed, for example, then try looking at the
spaces around these parts and draw those abstract shapes
instead. Think of the outline of the horse as just one part
of a jigsaw, surrounded by interlocking parts. It is another
tool in learning to observe, and you may be surprised by
how helpful it is.

What Skills Does It Use?

The core skills of looking, seeing edges, relationships,
and shapes.

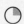 **1–2 minutes**

Mark-Making

Draw lines using an HB or B pencil, working carefully from
observation. Shading the negative areas can be helpful.

How to Improve

Practice looking for negative spaces around and between
objects. Use a viewfinder (see page 27) to identify the spaces
around the horse.

C: INTERNAL NEGATIVE SPACES

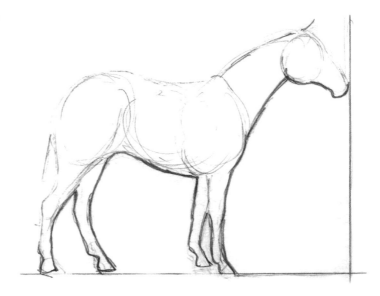

D: EXTERNAL NEGATIVE SPACES

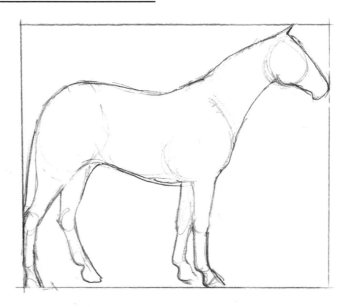

Parallel Stage: Problem-Solving

What Is "Problem-Solving"?

This is a good time to step back and assess your drawing, as it can still easily be changed at this stage. Call upon your internal tutor (see page 23) to help you decide whether the lines and shapes are accurate. Take a break and come back to your work. Hang the drawing up and look at it from a different viewpoint or look at it in a mirror.

How to Check for a Problem

The easiest way to check a drawing is to look at the negative shapes. This way you are not distracted by detail on the form. Then use observational measuring (see page 26) to check relationships between the parts. The length of the horse's head is usually the same length as the withers to the girth, for example. You can use the proportions sketch (below) as a guide. For now, use your measuring skills to compare your drawing with the subject. If anything needs to be changed, erase your lines and redraw. Partially erase your construction drawing before going on to Stage 3.

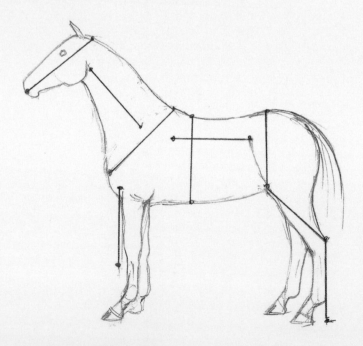

Look at: spaces and shapes

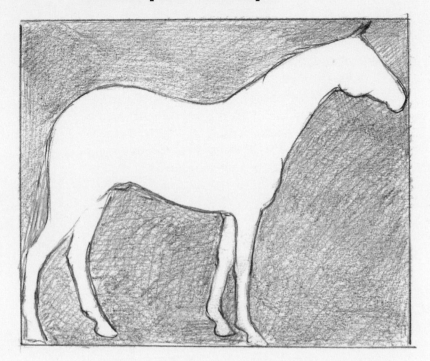

Look at: verticals and horizontals

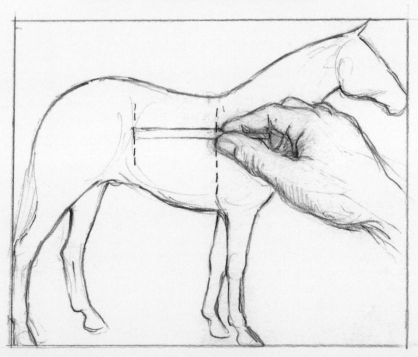

Stage 3: Elaborate

What Does "Elaborate" Mean?

Once you are happy with the construction stage of your drawing, and have softly erased it back, you can start to strengthen the shape of your drawing, and to add surface detail such as light and shadow on the form of the horse, any markings on its coat, and features such as eyes, ears, and nostrils, and the mane and tail. You decide how much you want to include. A simple line drawing with the hint of a feature and a smudge of tone can be as effective as a fully worked piece. Remember the flow of the original establishing sketch and work with that energy even though your mark-making is more precise at this stage.

What Skills Does It Use?

Use the core skills of linear drawing and recognizing spaces and tone in the shadows within the subject. Also be aware of the tonal pattern in the coloring of the subject. This is the time to make creative and imaginative decisions about what to select and emphasize in your drawing.

◔ 5–10 minutes

Mark-Making

Experiment with different grades and different ways of using your pencil to create hatching and parallel lines (see page 34) to reflect form, tone, and different textures. Some of your marks will be quite precise; others, loose and flowing. See the Chapter 5: Going into Detail (from page 80) for more on finishing touches.

How to Improve

At this stage the drawing becomes more about self-expression. As you practice, you will find that you prefer certain kinds of mark-making and media, and you will become more confident in what you want to say and emphasize in your drawing. Always be open to trying new approaches. You might be surprised.

A: ELABORATING ON LINE

B: ELABORATING ON TONE

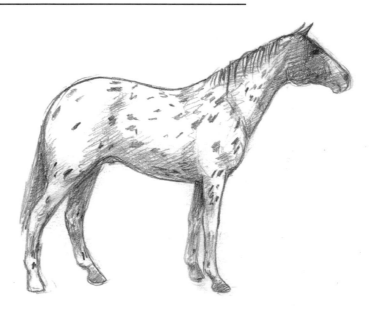

C: ELABORATING ON FEATURES

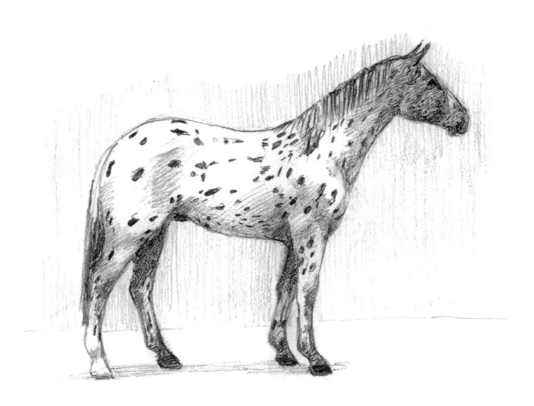

D: FINISHING TOUCHES

Strong graphic
line to make body
stand out

Vertical tone to help
figure stand out

Darkest darks
in the eye

Hard edge of
body broken
with fur marks

Shadow to
ground figure

Tone used to help
distant leg recede

Putting It All Together

Here is the whole process in step-by-step form for you to refer to when you practice.

Remember: keep looking!

STAGE 1

ESTABLISH

A: GESTURAL SKETCH

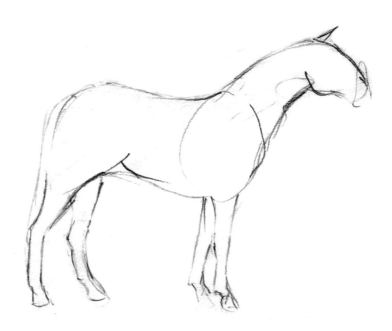

B: ERASE

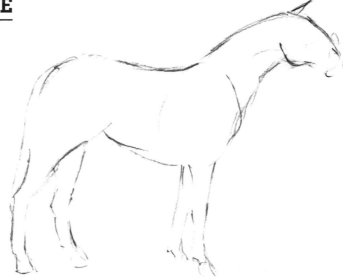

STAGE 2

CONSTRUCT

A: BASIC INTERNAL SHAPES

Think about anatomy.

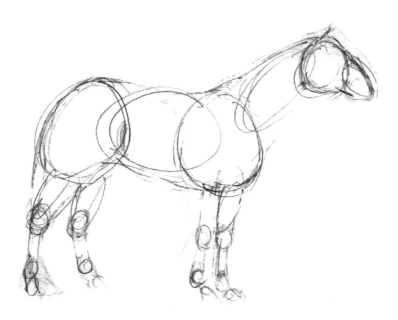

B: FLOWS BETWEEN SHAPES

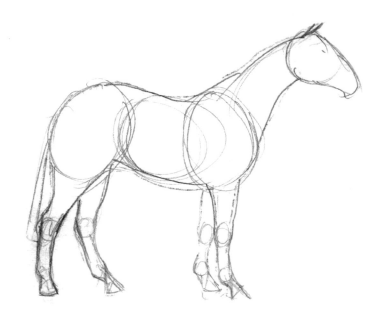

C: INTERNAL NEGATIVE SPACES

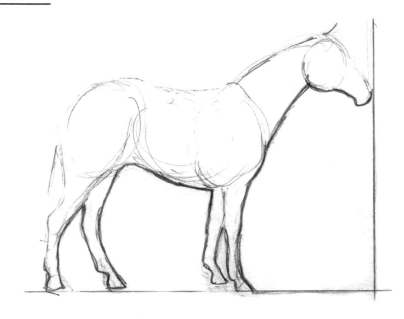

D: EXTERNAL NEGATIVE SPACES

Problem-solve; check, erase, and redraw if needed.

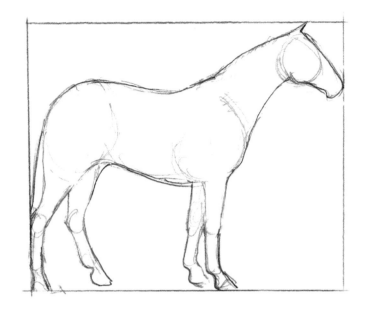

E: ERASE

A: ELABORATE ON LINE

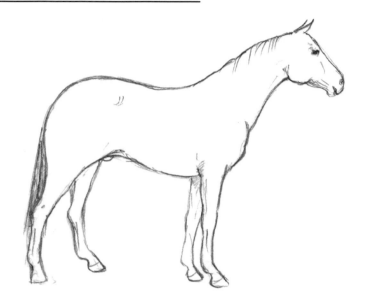

B: ELABORATE ON TONE

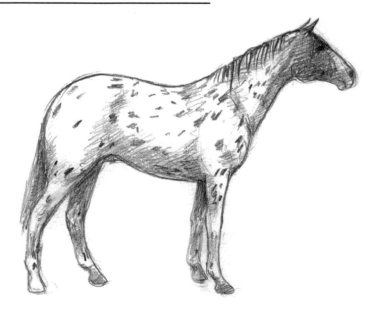

C: ELABORATE ON FEATURES/ FINISHING TOUCHES

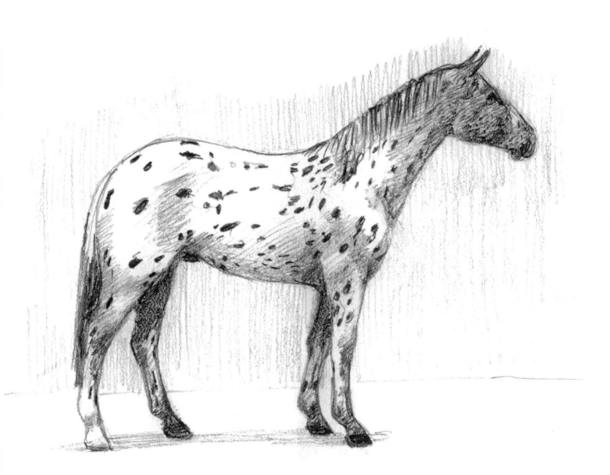

Putting It into Practice

Here is a set of exercises that will help you to practice and consolidate the stages of establishing, constructing, and elaborating that we've been working through. Whether you are a beginner or a more experienced artist, I suggest that you work through the exercises in sequence, keeping to a time limit of 15 minutes. If you find some exercises challenging, return and practice them until you feel more confident. Concentrate on the skills you are learning rather than worrying too much about the results for the moment.

Exercise 1: Practice the Technique
This exercise will help you to become so familiar with the three-stage technique that it becomes second nature, and can be used to draw any subject.

Exercise 2: Quick Sketches
This will help you to work spontaneously, improving your establishing drawings, as well as teaching you to look.

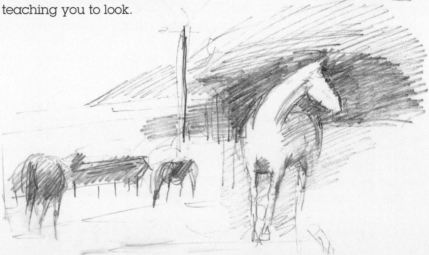

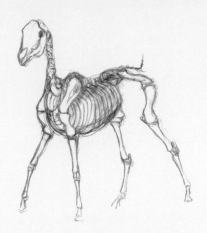

Exercise 3: Anatomy of a Horse

How well do you really know the basic anatomy of the horse? Try this exercise to explore your knowledge and gain confidence in your construction drawings and problem-solving.

Exercise 4: Negative Spaces

Focus on negative internal and external spaces to help your construction drawings, and develop your inner tutor to help with problem-solving.

Exercise 5: Draw a Horse in 15 Minutes

Practice your skills in all the techniques to make a longer and more detailed study.

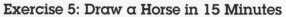

Exercise 1: Practice the Technique

What you need:

🕐 **15 minutes**

AIM

This exercise is an opportunity to practice the three-stage
process by drawing a neutral, everyday object.

WHAT TO DO?

Set up carefully, making sure you have a good, well-lit view
of the subject, and that you have your materials prepared
and to hand. You can use any object as your subject, but
don't go for anything too difficult to begin with—here I've
just used a simple snaffle bit. Work through each step,
looking carefully at the subject, and try to complete
one drawing within 15 minutes.

Look

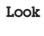

1: Establish

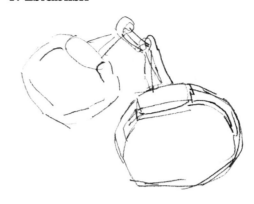

Erase

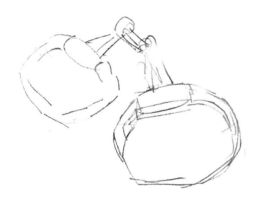

2: Construct

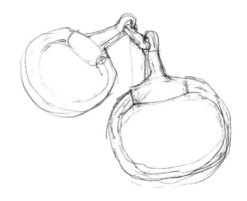

Erase

3: Elaborate

Exercise 2: Quick Sketches

What you need:

🕐 **15 minutes**

AIM

Quick sketches are a wonderful and fun way to record
observations without the pressure of trying to create a
finished drawing. The aim is to practice your observational
and drawing skills, working quickly and spontaneously.

WHAT TO DO?

Prepare your materials and commit to work for 15 minutes,
in which time you will try to fill a page. Even if you find
the constant movement of the horse frustrating to draw,
stay patient and keep going—this is a great exercise in
looking, and a chance to engage with the living subject.

Use the establishing skill of the gestural sketch, and
the constructing skill of drawing main shapes and flows
between them to make your sketches. A basic awareness
of the line of the spine and the shapes of the head, shoulder,
and hindquarters will help you grasp a pose, so this is also
a great chance to apply and check your knowledge of
anatomy. If you get a chance (if the horse repeats a pose
or stays still), continue with your constructing skills, looking
at negative internal and external shapes. If possible, move
around the subject to get different viewpoints.

Fill a page with quick sketches, not worrying if your
drawings are incomplete or overlap. They will be good
source material later on! Remember the focus and energy
involved in making these sketches and use it in all your
work, even when drawing from photos or other sources.

Fill a page with quick gestural studies

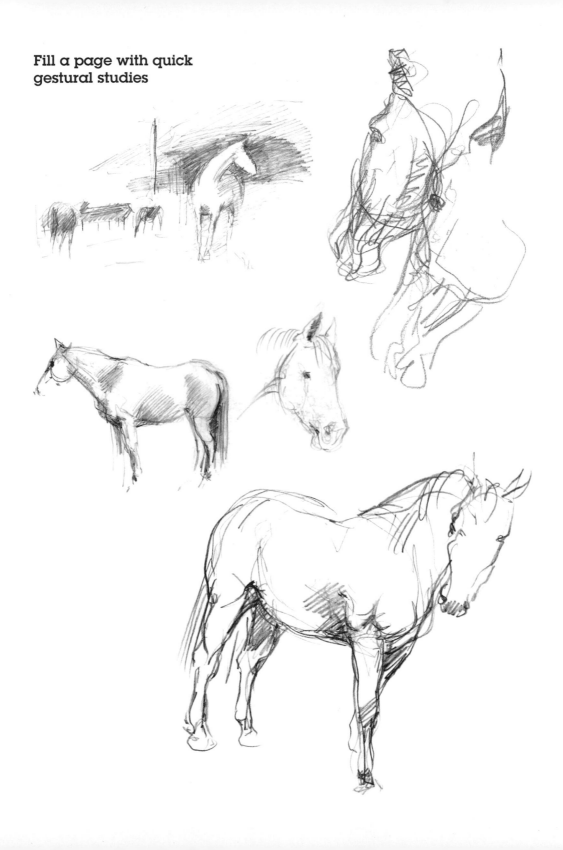

Exercise 3: Anatomy of a Horse

What you need:

🕐 **15 minutes**

AIM

This exercise helps you to understand how the skeleton of the horse influences its external appearance. The method can also be applied to drawing any living thing.

WHAT TO DO?

Find a clear photograph or drawing of a horse. Use any source, and enlarge or reduce it by photocopying it if necessary. Letter size (A4, 8½ × 11 inches) is ideal.

Do some research and collect diagrams of the equine skeleton. Take some tracing paper and tape it securely over the image, then draw an outline of the main body shape of the horse. Within this outline draw the bone structure, keeping to the 15-minute time limit.

This is an excellent way of really grasping how internal structure affects appearance, and to check your drawings at the construction stage. Look at the various parts from different angles so that you begin to understand the form, and practice until you have a good enough understanding to draw a "stick horse" skeleton from memory from any angle. This exercise can also be used to learn the muscles of the horse.

Place tracing paper
over drawing

Draw the horse's skeleton

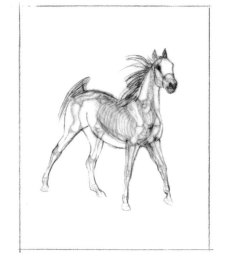

Learn to draw "stick horses"
to help with your construction

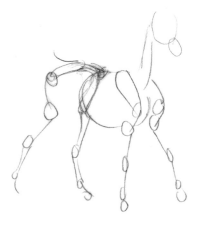

Exercise 4: Negative Spaces

What you need:

🌓 **15 minutes**

AIM

This exercise will help you to see the subject and its
surroundings in terms of abstract shapes (see page 48).
By looking in this way, you are using a different part of
your mind, free from associations and memories that
might be preventing you from seeing the actual shapes.

WHAT TO DO?

Set up to draw from a photo (see page 18) with a picture
that has a lot of negative shapes—for example a group
of horses, where the legs are defined. Use a viewfinder
to establish the edges of your subject and frame this area.
Drawing to the same size as the original picture helps—if
necessary you can scan or photocopy it to alter its size. You
can make a grayscale copy of the picture so that you are
not distracted by color, and increase the contrast to help
you see the main shapes. Look at the image and start to
focus on it in abstract terms. Find a small in-between shape
to start with and draw it with a clear boundary, then move
on to the next shape and do the same until you have
identified and outlined all these internal shapes. Then
draw the external negative space around the outside of
the horse(s), and you will see its silhouette. If this is a new
way of drawing for you, you may find it difficult at first.
Practice as often as you need to.

Draw the first negative shape

Find adjacent shapes to draw

Look at the outline of the horse

Exercise 5: Draw a Horse in 15 Minutes

What you need:

🕐 **15 minutes**

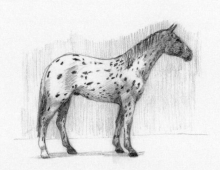

AIM

This exercise is an opportunity to use all the techniques described in this book so far.

The techniques each involve some knowledge and experience, so it might take you a little while until you feel comfortable with the method and start to explore your own personal language. Even if you are an experienced artist, you will learn much from using these techniques. One of the fascinating aspects of being around horses is the infinite amount there is to learn, and practicing art is the same.

WHAT TO DO?

Prepare to draw from a photo or a reliably still held model. Start by looking at the image or subject and planning where to place it on the page. Don't worry too much if you end up going off the edges of the paper, but do try to fill most of the page.

Use the three-stage approach of establishing, constructing, and elaborating, and try to stay within a 15-minute time limit for the whole process. You might not complete your drawing within that time at first, but keep practicing and you will soon gain confidence.

Look

1: Establish (10 seconds–1 minute)

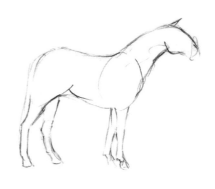

Erase

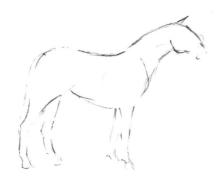

2: Construct (8–10 minutes)

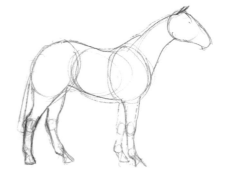

Erase

3: Elaborate (4–5 minutes)

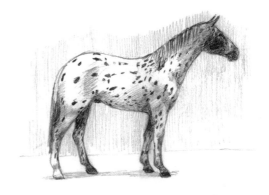

Exercise 6: Draw It from Memory

What you need:

 15 minutes

AIM

In this exercise you will build on what you have learned to create a drawing from memory and imagination. Memory and imagination are the powerhouses of art, and with a subject as mobile as a horse, you can't overestimate how often they will come in handy! This exercise will also test your knowledge and skills, and probably raise some questions about observation and accuracy to return to in your next study.

WHAT TO DO?

Take one or more recent drawings and set up with a board, several sheets of paper, and a variety of materials to work with. Have a good look at one of your drawings, and then hide it from view. Make the drawing again from memory, working as fast as you feel comfortable—allow yourself no longer than five minutes to get something onto paper.

Now have another look at the original drawing. You may find that your new drawing is exaggerated in places, or less accurate than the original. Hide the original again and do some more drawings, thinking about how you can improve on your first attempt.

Finally, make one more set of drawings referring only to the memory drawings. Have fun with this—give rein to your imagination and energy, and experiment as the drawing gains its own momentum. This exercise is a great way of practicing your anatomical understanding, as well as discovering what you want to focus on in a drawing.

You can take this exercise further by thinking of a context to fit your drawing into. It could be based on your knowledge or experience of horses. Use your drawings to illustrate an event or scenario. You can even cut out paper shapes and move them around, or you can be abstract— think of the negative shapes or tones and make them into a pattern, or just use line.

Original drawing

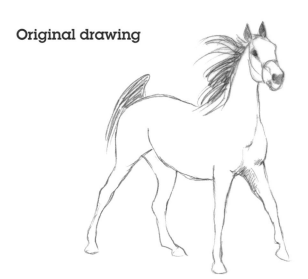

Draw from memory 1

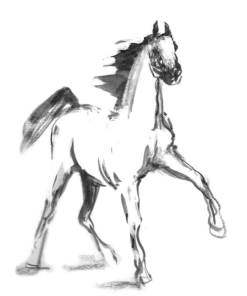

Draw from memory 2

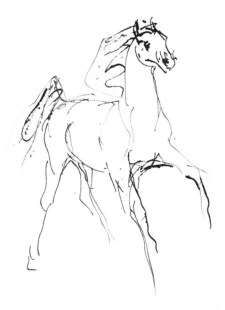

Making Pictures

There are many different reasons for making a drawing. You might want to explore the tonal structure of the subject or the mark-making possibilities of using only varying qualities of line. Maybe you want to make a visually pleasing portrait of an individual horse, or you could be exploring the possibilities of a new medium.

It is a good idea to know your intention before you start, although this can change as you work. Drawing is a combination of thought and decision and intuition and chance, along with a dynamic engagement with the subject. Often you don't fully realize what attracted you to a subject until you start to draw. The texture of a mane and tail might draw you in, but you may find that the contrasting tonal pattern of the horse in its field is your real subject. Taking time out to work from memory (see page 74) now and then will help you to focus on what it is that intrigues you about a subject, and re-fire your enthusiasm. Don't rush, but take a moment to pause and ask your internal tutor to help you decide your next step.

A Picture for Practice

Making drawings for practice is a great way to simplify the equation and just concentrate on developing your core skills as an exercise. Here you are not trying to express yourself directly or achieve a particular outcome, you are looking and translating that onto paper.

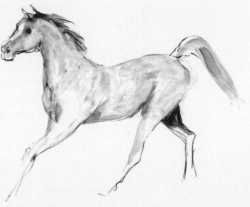

- If you want to focus on the form of the horse, then use the core perceptual skills of seeing shapes and tone, and try different kinds of mark-making.
- A detailed textural study, for example of the mane of the horse, will require the core skills of seeing line and tone, and the use of fine line.
- If the horse's pose interests you, concentrate on line, using different media and mark-making techniques.

Making a Special Picture

You may be asked to make a portrait of an individual horse. This is the chance to be clearly aware of and, if necessary, question your intentions. Decide on your approach, and think about who the drawing is for and how they would want their horse represented. Many people expect animal drawings to be quite realistic, and you can achieve this by following the three-stage method as outlined in this chapter. Gradually build up toward the finished drawing, erasing between stages, taking into account the scale of the drawing and size of paper, and how to show the horse to best advantage. Making such a study is always good drawing practice for the artist and will give pleasure to and be valued by the viewer. You may find that your friend or customer prefers a more contemporary look— this is your chance to experiment with your own style as it develops; making, for example, a simple line drawing to express movement, or perhaps a more complex tonal study, or zoning in on a detail such as the eye.

Avoiding Cliché

Equestrian art is often quite traditional, as it aims for a photographically realistic representation of an individual animal, and the results can be sentimental or nostalgic. Such art does take a great deal of skill, knowledge, and preparation to do well, and the artist is justly valued for the end result. It is a question of individual taste, and if you prefer trying different ways of depicting horses and exploring their relevance and meaning to us in the contemporary world, then experiment for yourself; talk to your friends, and look at the work of as many other artists, past and present, as often as you can.

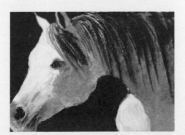

Foreshortening and Perspective

What Is Perspective?

In drawing, perspective is a technique
for representing depth on a flat surface
such as a sheet of paper. To understand
how it works, look out of a window and
use the horizontal or vertical measuring
method (see page 26) to compare the
size of a distant tree or building outside
with a small object, such as a cup, inside.
You are likely to find that the tree and
the cup measure a similar length. Linear
perspective is a practical tool to ensure
that such optical illusions created by
distance are constructed accurately to
make a convincing image.

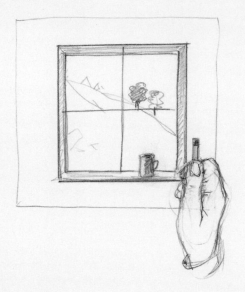

Vanishing Points and Horizon Lines

The visible or imaginary horizon line of your drawing
runs parallel to the top and bottom of your page. It might
be at your eye level, above, or below it, depending on the
viewpoint you want to present. A high horizon line will
mean you are looking down on your subject, and a low
horizon line gives a view from beneath. All the parallel
lines in your drawing will converge on a vanishing point—
one imaginary point often behind the picture plane.
You can use the position of these lines to ensure that
your objects are the right optical size.

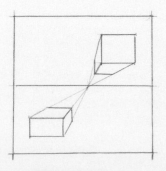

Horizon at eye level

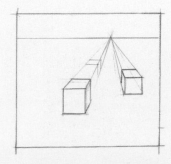

Horizon above eye level

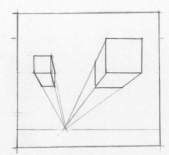

Horizon below eye level

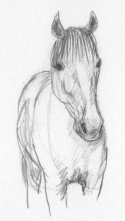

What Is Foreshortening?

When you are just starting out it might not seem terribly important, but you will soon discover how useful it is to have a basic understanding of perspective. Even in the shallow picture plane that is the side view of a horse, you will notice in your observations that the position of the far front and back hooves appears slightly higher than the nearer hooves. This is perspective at work, and it becomes much more marked once you draw the horse from an angle, or from in front or behind. The optical effect you experience in these views is called "foreshortening." Because a horse is a large and long animal, these perspectival distortions can be very marked. This can add to the drama of the drawing. Your horse's head can seem enormous when looked at from the front, in contrast to its hindquarters—just like the tree and the cup.

If you are observing carefully when drawing, you will take perspective into account without being aware of it. The problem is that if the horse is moving it will be more difficult to work out and you will be tempted to fall back on your "mind knowledge," which is informing you that the hindquarters are larger than its head, and the hooves are on the same level on a flat surface. Correct in terms of reality, but completely wrong for your drawing. A basic awareness of perspective will help you understand the illusion, and will also be handy if you want to include further context in your drawing, such as fences, stable buildings, or other horses.

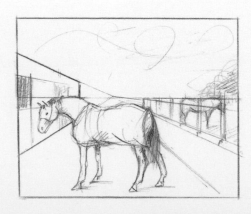

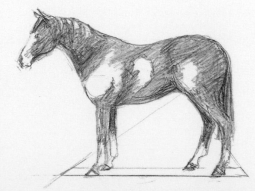

GOING INTO DETAIL

Anatomy of the Head

The expression and beauty in a horse's head is something
we would all like to capture in our drawings, and this
begins with getting the anatomy right. More than most
other animals, the horse shows its underlying anatomy
very clearly, and this is particularly evident in its head.
If you know the basic shape of the skull, and can use this
knowledge in the construction stage of drawing, you will
find that your equine portraits will improve rapidly.
Characteristic shapes to watch out for include the eye
socket and the zygomatic arch above it, the masseteric
ridge on the side of the face, the large jawbone, and the
frontal and nasal bone.

The upper part of the skull is more rigid than the lower
nose and muzzle area, which is much more mobile and
consists of much more soft tissue, muscle, and tendons. All
these are visible on the surface and you can see them in
action by watching a horse eating. (More about the jaw
and nostrils further on.)

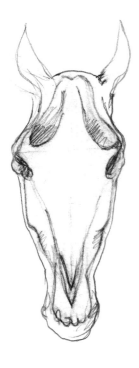

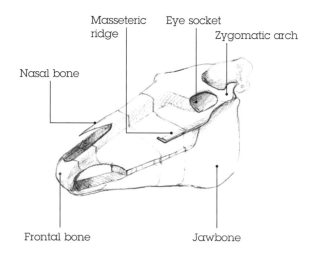

Masseteric ridge · Eye socket · Zygomatic arch · Nasal bone · Frontal bone · Jawbone

The hair on the horse's head is usually smooth and short with whorls on the forehead.

All horses have the same skull structure, but size and weight varies according to breed. The Clydesdale head is huge in comparison to the Arabian or a pony, while the Appaloosa falls somewhere in between. Use the core skills of looking and measuring to get the proportions accurate, and practice the anatomical overlay technique (see page 68). The skull and head of a horse is complex, and it is a good idea to practice drawing it from different angles—from the front, side, and rear.

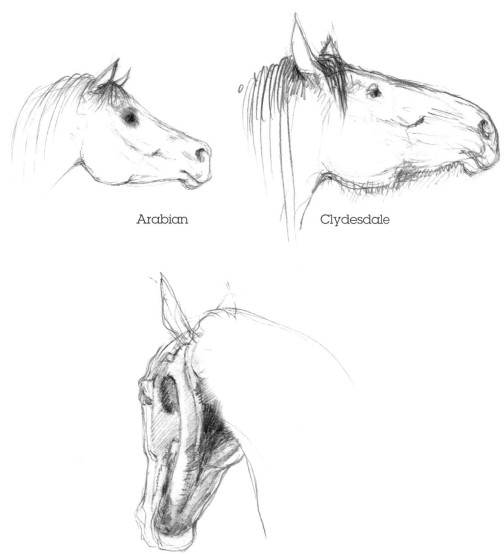

Arabian

Clydesdale

Faces

Draw the whole head before going into further detail, so that you grasp the overall shapes and relationships between the main parts of the head. Use observation and the core skills to create a basic portrait from life or other sources (photos or books), particularly considering the underlying bone structure and the internal proportions of the horse's head. There are standard rules of proportion that you can refer to as a check for your drawing, but remember that horses vary as individuals as well as according to their breed or type. Looking, understanding, and intuition are all equally important.

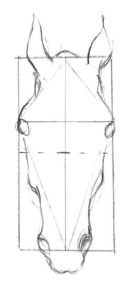

Basic Portrait

1: **ESTABLISH**

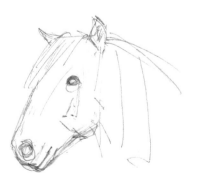

2: **ERASE**

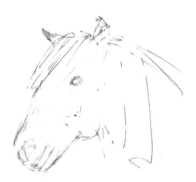

3: CONSTRUCT

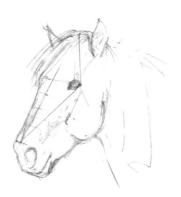

4: ERASE

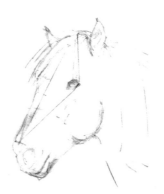

5: ELABORATE

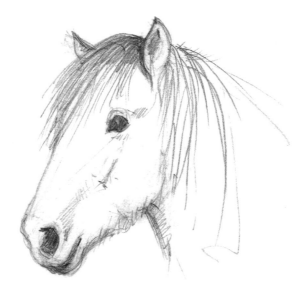

Eyes

The windows to the horse's soul! The horse has beautiful large dark eyes, the largest of any land mammal. Some horses have blue or light eyes, but it is a rare genetic occurrence (which may be encouraged in some breeds). The dark pupil/iris fills the visible part of the eye socket except for a flash of white when the horse rolls its eye to express fear or uncertainty.

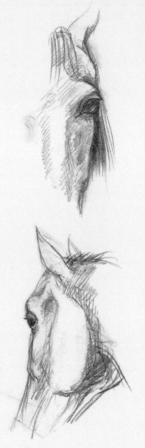

When drawing this feature, think of how the spherical eye fits within the socket, and be aware of the muscle structure, including the eyelids (and eyelashes), around the eye. The horse has peripheral vision, and its eyes are angled at the side of its head, with the brow forming a pronounced shape. This makes for interesting viewpoints from front, side, and back. Try drawing from different positions so that you capture these viewpoints.

It takes time for anatomical understanding to become second nature when you are drawing, so the more you can practice and study, the better. An internet image search for "horses' eyes" will be a helpful source of information, particularly about the soft tissue and the protruding bone structure surrounding the eye.

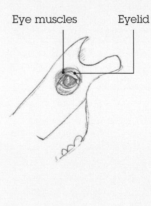

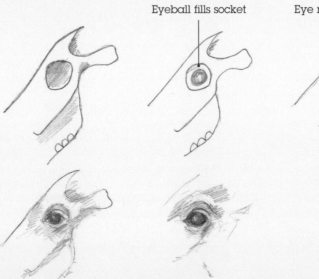

Eyeball fills socket Eye muscles Eyelid

1: ESTABLISH

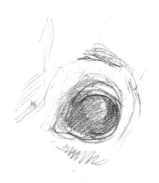

2: ERASE

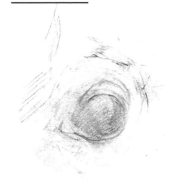

3: CONSTRUCT

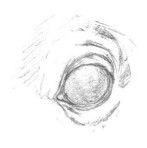

4: ADD MID-TONES

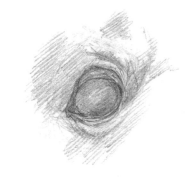

5: DARKEN SHADOWS

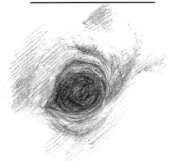

6: ERASE TO HIGHLIGHT

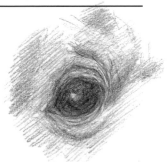

Ears

The horse's ears are an important feature of its head. A horse's hearing is acute and it constantly uses its ears to pick up information about its environment and to signal its emotions and intentions. As many riders will be aware, the position of the ears is a reliable indicator of where their horse's attention is. The ears are extremely mobile and can move independently.

The Shape of the Ear

Think of the ear as a triangular funnel, closed at the base, and attached at each side by the muscles of the head. Noticeable is the S-shaped curvature on the inside edge of the funnel. The ears are surprisingly large—about a quarter of the overall length of the head from poll to muzzle depending on breed—and disproportionately large in a foal.

Triangle folded This edge is more S-shaped

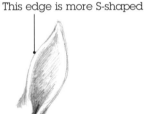
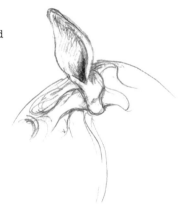

The basic construction of the ear, and the shape and anatomy of the ear as seen from the side.

Horses' ears differ considerably between breeds, from the large, thin ears of the English Thoroughbred to the small bushy ears of the Icelandic horse, and everything in between.

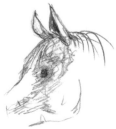

Drawing the Ears

1: ESTABLISH

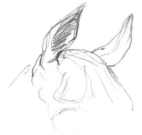

2: ERASE

3: CONSTRUCT

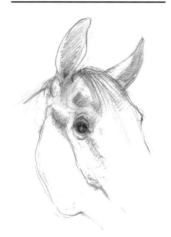

4: ERASE

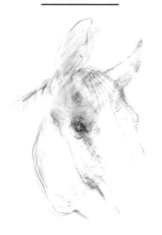

5: ELABORATE ON LINE

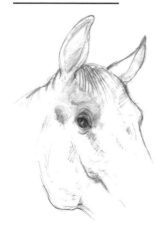

6: ELABORATE ON TONE

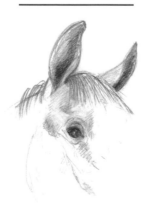

The Nose and Muzzle

The horse has a highly developed sense of smell, and the large, expressive nostrils that come with this. The nose and muzzle are made of cartilage, skin, and muscle, and they are the only parts of the horse's head not clearly defined by the underlying bone structure. Watch a horse eating and you will clearly see the mobility of the lower jaw and mouth in comparison to the upper part of the head.

The Nostrils

Like all mammals, a horse's nostrils are held in place by semicircles of cartilage attached to the front of the nose. Horses also have a pocket of skin partially covering the opening, known as the "false nostril," which flares open when the horse is exerted to allow it to breathe more deeply through the true nostril. Once you begin to see how the semicircular cartilage is the main foundation of the nostril rather than the more obvious "false nostril," it will become easier to draw this feature accurately. Try drawing from life if possible, and draw from different angles, keeping the anatomy in mind, until you feel confident you have understood it.

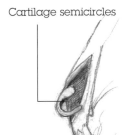

Cartilage semicircles

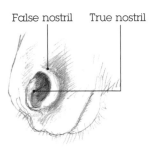

False nostril True nostril

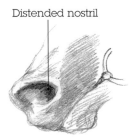

Distended nostril

The muzzle is a highly sensitive part of the horse, used to communicate with other horses and to explore the world. It is a good idea to study the muzzle from life or a photo to get to know the main shapes, such as the upper and lower lip and the nostrils. Note the muscular tip of the nose, the slight wrinkling of the skin between the nostrils and on the lips, and the whiskers on the muzzle.

Drawing the Nose

1: ESTABLISH

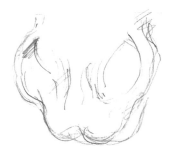

2: ERASE

3: CONSTRUCT

Cartilage semicircles

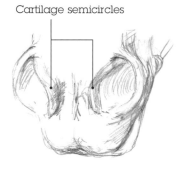

4: ERASE

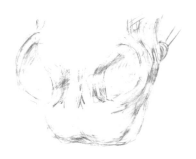

5: ELABORATE ON LINE

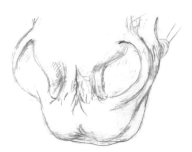

6: ELABORATE ON TONE

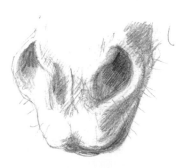

Legs and Hooves

The Lower Leg

The characteristic shape of the horse's leg is very clearly derived from its underlying structure of bones, muscles, and tendons. From the knee downward, the leg is composed only of bones, tendons, and cartilage, visibly defined on the surface in many horses. The pastern and fetlock joints are extremely flexible, sometimes in a position that's almost parallel to the ground if the horse is going at speed.

Horses' Hooves

As the saying goes: "No foot, no horse." Healthy hooves are vital to a horse's mobility and survival, and to the artist they are an important visual feature. The inner foot is an extension of the skeleton, and it is surrounded by a hard hoof around the sides and front, and by cushions of cartilage at the back. Think of the fetlock and pastern as part of the horse's foot, and of the hoof itself as a shallow cylinder, which is affected by perspective; particularly when the horse is moving its feet. Study the anatomy of the lower leg and foot until the shapes and relationships becomes second nature to you, and practice by drawing both from photographs and from life.

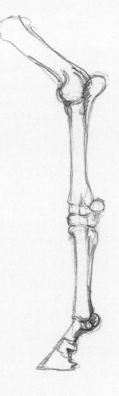

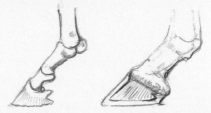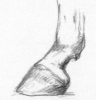

Anatomy of a horse's foot

A horse's hooves in perspective

Look at the underside of the hoof as well, because in the moving horse this is the surface you see as it walks, jumps, trots, or gallops. Often the horse will be wearing metal shoes—the universal symbol for the horse and for good luck!

Drawing the Feet

1: <u>ESTABLISH</u>

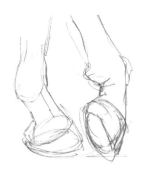

2: <u>ERASE</u>

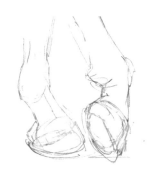

3: <u>CONSTRUCT</u>

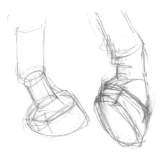

4: <u>ERASE</u>

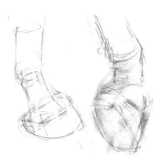

5: <u>ELABORATE</u> <u>ON LINE</u>

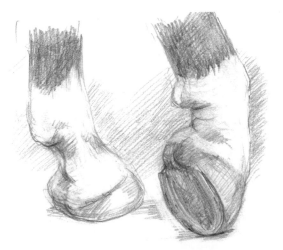

Forequarters and Neck

The horse naturally carries more weight in its front end, and the front hooves are bigger than the rear hooves to support the massive shoulder and chest structure, as well as the neck and head. It is a good idea to have an outline idea of the anatomy of the neck, chest, and shoulder area when you are drawing, but keep it simple at first. The main thing is to understand the basic underlying structure of the bones. There is no need to know their exact shapes, just their approximate length and location.

Think of the horse's thorax (the rib cage area) as a cylinder, slightly narrower toward the front of the horse, and with a large curved protuberance rising up like a ship's keel at its lower front (see drawing on page 93). The top of this "keel" is the foremost point of the body, well in front of the shoulder, and you can feel it easily on the horse's chest. The neck vertebrae enter the thorax at the upper end and continue along the spine. The shoulder bones (scapula and humerus) are connected to the thorax only by muscles and ligaments, not by skeletal joints.

The horse has complex, well defined muscles around the neck area. If you can establish an outline of the shoulder bones and the upper leg bones, you will have grasped the structure of this part of the horse. It is then simple to insert the main muscles. With this knowledge, you will be able to draw the forequarters from any angle, understanding the complex surface appearance of this part of the horse. Practice will make perfect!

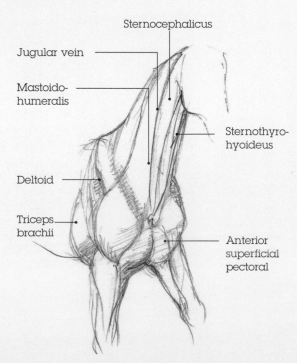

Sternocephalicus

Jugular vein

Mastoido-humeralis

Sternothyro-hyoideus

Deltoid

Triceps brachii

Anterior superficial pectoral

1: <u>ESTABLISH SKELETON</u>

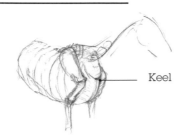

Keel

2: <u>ERASE</u>

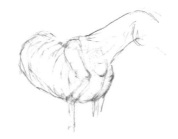

3: <u>ESTABLISH MUSCULATURE</u>

4: <u>ERASE</u>

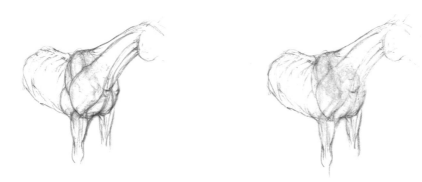

5: <u>ELABORATE</u>

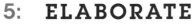

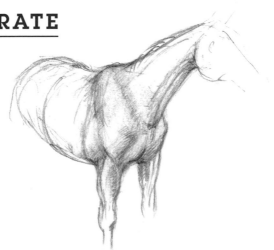

Hindquarters

As the engine of the horse, the hindquarters contain large, powerful muscles, some deep, and some more visible on the surface. The solidity and size of these muscles conceals the complex bone structure underneath. As with the forequarters, it's helpful to establish an outline idea of the underlying mechanics of this area. Don't worry too much about getting details right, just set down the main shapes.

Think of the pelvis as a wide, tilted plate attached to the femur, where the leg begins. This will help you to understand the volume of the quarters and the position of the back legs. Once you have constructed the basic framework, you can think about the muscles and develop your drawing, using tone and line to show the form.

Tuberosity on hip
Trochanter major
Ischial tuberosity
Femur

Tuberosity on hip
Sacrum
Ischial tuberosity
Ilium
Trochanter major
Femur
Patella
Tibia
Hock joint
Metatarsal bone

Tensor fasciae latae
Gluteus medius
Long vastus
Semitendinosis
Biceps

Drawing the Hindquarters

1: <u>ESTABLISH</u>

2: <u>ERASE</u>

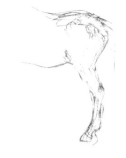

3: <u>CONSTRUCT</u> <u>SKELETON</u>

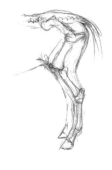

4: <u>CONSTRUCT</u> <u>MUSCULATURE</u>

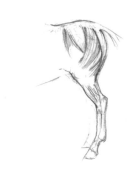

5: <u>ERASE</u>

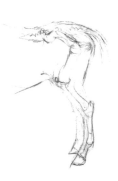

6: <u>ELABORATE</u>

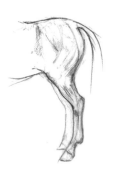

Manes and Tails

The horse's mane and tail are beautiful features that look most spectacular when the horse is moving. Both features are important in conveying a sense of the character of the horse. Some horses have fine, silky manes, and others have heavier, thicker hair. The mane may fall on one or both sides of the neck, and it might be braided in various ways for shows and competitions. Similarly, the forelock may be sleek, or braided, or thick and falling over the horse's eyes. Horses often swish and flick their tails as an expression of emotion; mostly annoyance or frustration.

The mane often follows the contours of the neck, and it always grows slightly upward before falling to the side, so try to get that movement into your drawing. Remember that the mane and tail will usually create shadow, and you can use this to give volume to your drawings.

To draw the mane and tail, first establish the main shapes, then add the texture of the hair. Use long, curved marks drawn from the wrist (see page 30) to create a sense of movement. Don't worry about being completely accurate, but aim to get a feeling of flow and texture. Add shadow—either cast shadow, or the shadow within strands of the mane or tail itself—then erase and draw lightly to indicate small strands of hair. Elaborate by developing the shadow and erasing to create highlights.

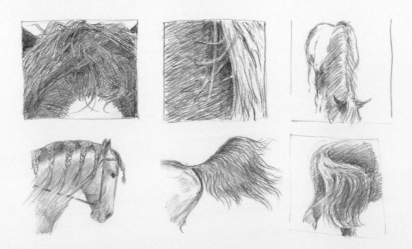

1: <u>ESTABLISH</u>

2: <u>ERASE</u>

3: <u>CONSTRUCT</u>

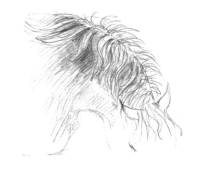

4: <u>ERASE</u>

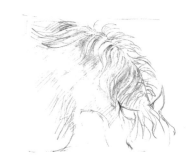

5: <u>ELABORATE</u>

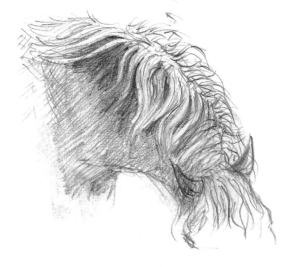

Age and Gender

The young foal has very long legs and a small head
and body. Its skeleton is almost entirely cartilage at birth,
which, starting at the foot, gradually transforms into bone;
a process not complete until it is five to seven years old.
Foals have inquisitive natures and delicate dancing
movements, and they follow their mother everywhere.
As they grow, their body shape develops in proportion
to the legs.

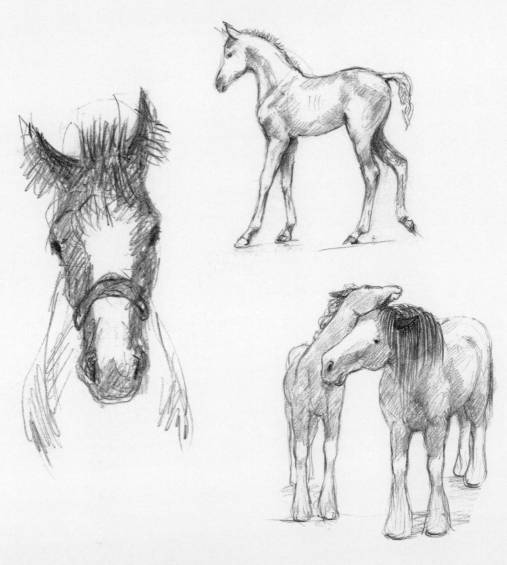

Most horses are backed to be ridden from three to four years, earlier in racehorses. Stallions are usually more muscular than the female, with larger necks. All horses are highly intelligent and alert, but the stallion usually more so. In old age, the horse will show characteristics such as a dipped back and sunken eye sockets.

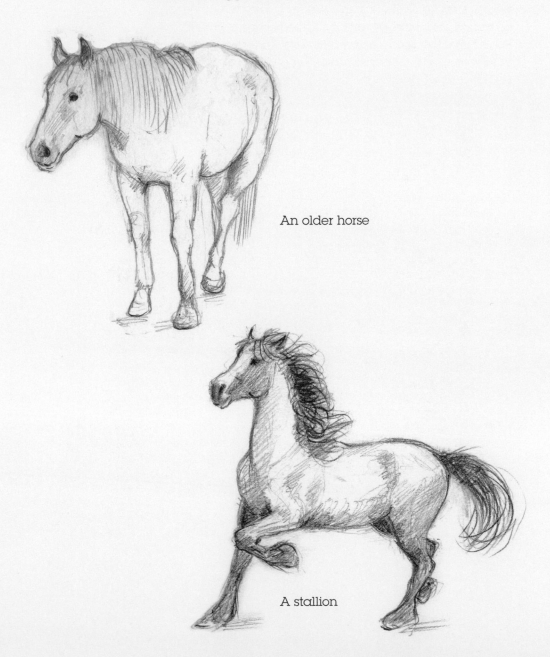

An older horse

A stallion

Gaits and Movement

Movement is the essence of the horse, whether the deliberate, slow power of the draft horse, the speed of a racehorse, the coiled-up strength of the show-jumper, the elegant control of the dressage horse, or the lively prancing of horses at liberty in the field.

The basic principle behind the movement of a horse is that the hindquarters push while the forequarters stretch out forward. The horse has four basic gaits (some breeds have an extra one): walk, trot, canter, and gallop; and the horse uses its legs, weight, and body differently for each. The walk is a four-beat gait; the trot, two-beat; the canter, three-beat; and a fast gallop, four-beat.

Walk

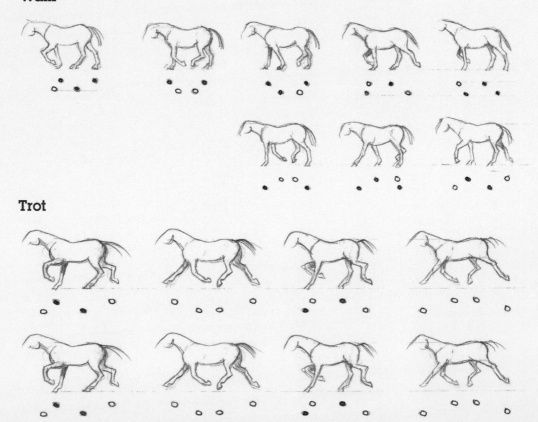

Trot

It is a good idea to study how a horse moves its legs for each gait in order to increase your understanding, and so that your drawings will be accurate. Drawing the moving horse from life and from photos is easier if you think of the anatomy (see page 68) and you are familiar with the gaits. Only in the late nineteenth century did Eadweard Muybridge's photography reveal the actual way the horse moves—it is too fast to catch by eye. Movement is exciting to express in a drawing, and you might also want to try the memory exercise (see page 74), checking back to your study and experimenting with different materials.

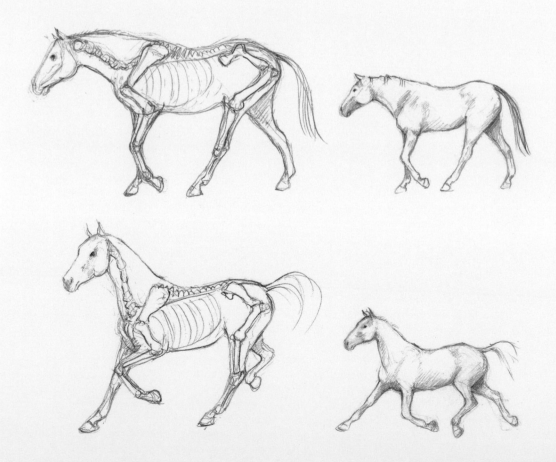

Canter

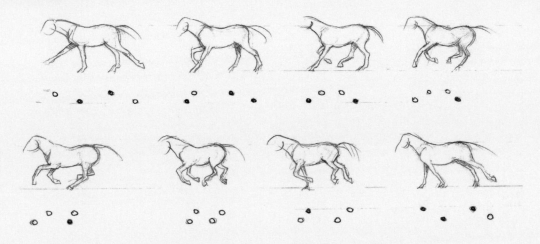

Gallop

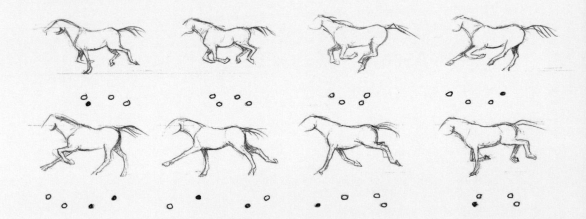

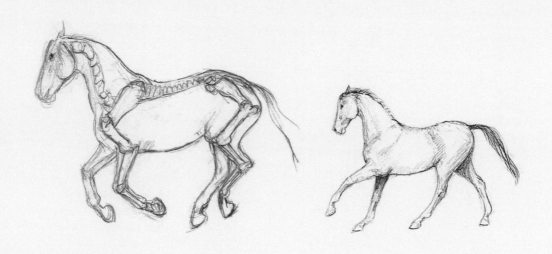

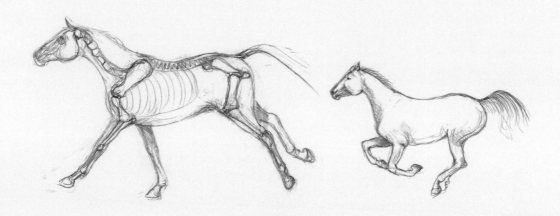

Horses and Humans

Humans and horses have been associated for around 6000 years, and until the twentieth century, horses were essential to our species. In time, the horse has increasingly become a companion animal, valued for its ability to offer a different dimension to the pace of modern life. Horses are prey animals, fundamentally different in nature from predators such as humans. Part of the pleasure of horses is in riding them, of course, but much can be learned and enjoyed by just being around them.

Use your interest in horses and your feelings for them as the drive for your drawings. Observing horses interacting with each other is fascinating, but watching them relating to humans is often very moving as well.

In the Stable and Paddock

Find a yard where you can observe horses being cared for, and try to express the bond and interaction between handler and horse in their daily routine. This is a good chance to practice both quick sketches and longer poses, and to do some movement drawings from life—as well as just to enjoy the presence of the horse.

The Horse at Work

The horse is today used for primarily for riding rather than haulage and agriculture. Riding the horse is an art: watch a good rider, in whatever field, and you will see the dynamic bond and mutual respect that exists between horse and rider. The horse indicates this in its posture and carriage, and in its concentrated facial expression and "listening ears." If you are a rider, remember the feeling, and try to keep that feeling in your drawings. It is not just the visual you are trying to draw, but also your sensations and emotions.

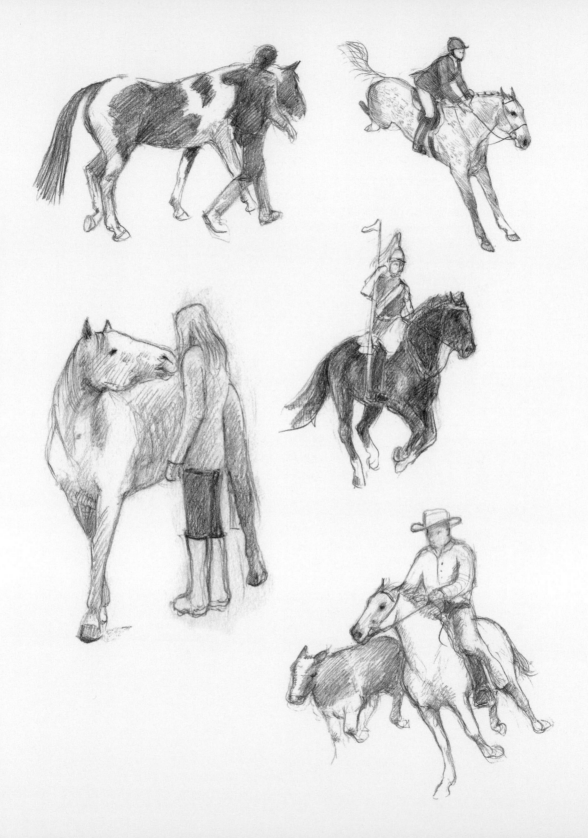

Different Breeds

Arabian

The daddy of them all, the Arabian horse has at some time been crossbred with almost every breed of horse in the world to improve stamina, conformation, quality, and soundness. The breed may date back to 3,000 BCE, and it is known that King Solomon kept 1,200 riding horses in his stables. Arabians, which are usually about 15 hands high (1.50 m) have fewer ribs, lumbar vertebrae, and tail bones than other horses, and this accounts for the distinctive shape of the back and the characteristic high tail carriage.

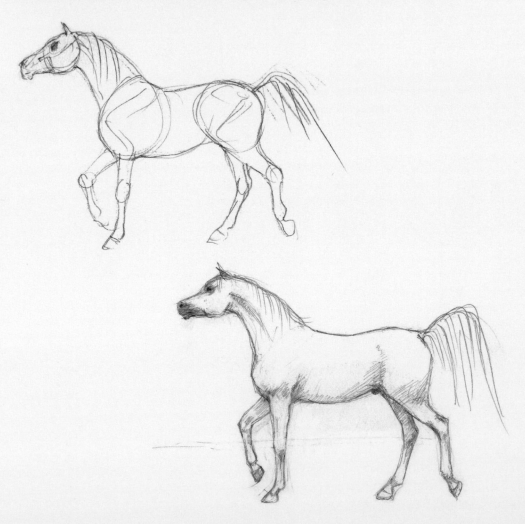

Baudet de Poitou

The French Poitou donkey is one of the largest donkey breeds. It can stand as high as 16 hands (1.60 m) and is bred with the Poitevin mare to produce strong, versatile mule stock. The Poitou has a very shaggy corded coat, which hangs in dreadlocks. Nowadays, as in this drawing, the coat is kept shorter for hygienic reasons, but here the jaw still has the thick characteristic hair under the chin.

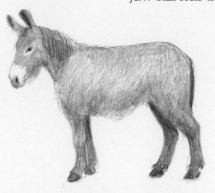

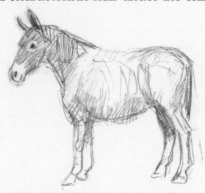

Friesian

The black Friesian horse from the Netherlands is a cold-blooded descendant of the primitive Forest Horse. It is an ancient breed, written about by the Roman historian Tacitus (c. 56–120 CE). It was used to carry knights to the Crusades, and became the most-used warhorse in the Middle Ages. Its influence has been widespread throughout Europe, and it is the direct ancestor of the English Shire horse. Strong, versatile, and lively, the Friesian is used as a working farm horse, driven in harness, and as a dressage horse.

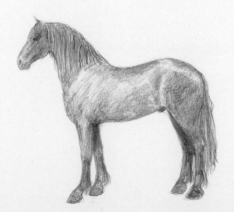

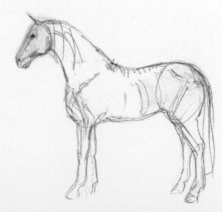

Morgan

This famous American breed originates from one stallion, Figure, who had prodigious qualities both as a hauling workhorse and as a racehorse. He was born in 1789 and came to be known as the "Justin Morgan horse," after his owner. His breeding is unknown, but it is possible that his sire was a Thoroughbred, a Friesian, or a Welsh Cob. He had many different owners, and was much in demand as a stallion. Eventually he became the founder of the first American breed, named after him.

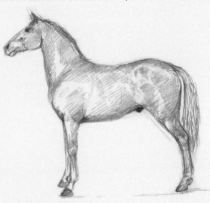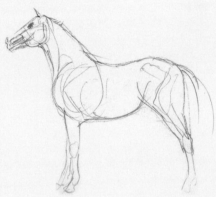

Percheron

It is said that French knights rode the ancestors of these horses at the Battle of Poitiers (732 CE) to a defeat of the Moorish armies from the south. The capture of the Moorish Arabian and Barb horses led to crossbreeding with the heavy Percheron and its bloodlines are now predominantly Arabian, even though its shape is so different. This means it can thrive in almost any climate, and has a long free striding action. It has been used for driving, farm work, as a warhorse, and as a riding horse, and makes a good base stock for crossing with other breeds.

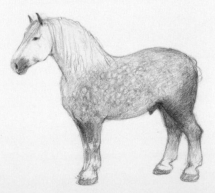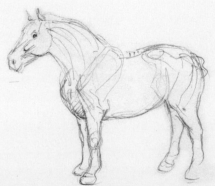

Pinto

Pinto coat patterns are either Tobiano, where the coat is white with patches of solid color, or Overo, where the coat is predominantly colored, with splashes of white. The Pinto or "Paint" are of no fixed breed, but the Pinto Horse Association of North America keeps a register of these horses, dividing them into stock types, hunter types, pleasure types, or saddle horses.

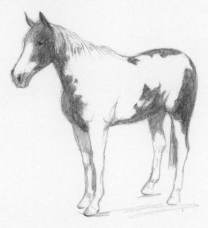

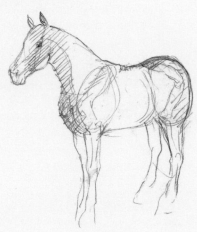

Shetland

The Shetland pony is thought to have existed since the Bronze Age and comes from the Shetland isles, to the north of Scotland. It is a small, hardy pony standing no taller than 11.2 hands (117 cm), and is usually black but can be almost any color. These ponies are extremely strong and can carry a fully grown man. They were used in the mining industry, and have been exported all over the world. Sometimes their temperament is a little uncertain, so they are not always ideal children's ponies, but they are often used as companions for other horses.

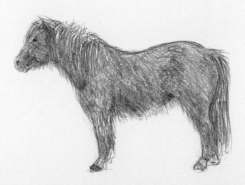

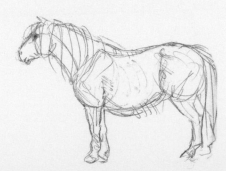

Exploring Drawing

I hope you have enjoyed this book and found it helpful and inspiring. Everyone learns differently and picks up different information in different ways. The main thing is to keep practicing and trying everything, and you will grow in confidence and find your own way. As you develop, you may return to this book and find that different sections have become more useful to you.

Keep Your Drawings

At first, you may feel frustrated by the results and want to throw your drawings away. It is better to keep them; later, when you look at them again, you will see how far you've come, and you can develop them further or draw over them with new knowledge and experience.

Drawing Communities

As you improve, it's a good idea to join a group of equestrian artists who will widen the scope of your work by holding teaching sessions or open exhibitions, as well as sharing your passion for horses. Preparing your work for exhibition is a great way to learn and focus and gain confidence. Remember that the framing and presentation is part of your artwork, so it is worth taking trouble with it.

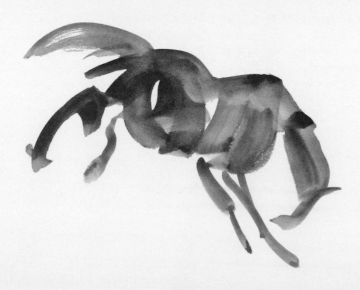

Bibliography

Bammes, Gottfried. *Complete Guide to Drawing Animals*.
Minneapolis: Book Sales Inc., 1994.
A superb introduction to animal drawing.

Calderon, Frank. *Animal Painting and Anatomy*.
Mineola: Dover Publications Inc., 1975.
*This classic book is unrivalled for its beautiful and
accurate anatomical detailed pencil drawings.*

Civardi, Giovanni. *Drawing Light and Shade:
Understanding Chiaroscuro*. Tunbridge Wells:
Search Press Ltd., 2006.
An extremely helpful book for understanding tone.

Ellenberger, W. *An Atlas of Animal Anatomy for Artists*.
Mineola: Dover Publications Inc., 1966.
A useful reference with detailed illustrations.

Muybridge, Eadweard. *Animals in Motion*. Mineola:
Dover Publications Inc., 2000.
*Muybridge's methods showed for the first time how
the horse moves at speed. Highly recommended.*

Pedretti, Carlo. *Leonardo da Vinci: Drawings of Horses
from the Royal Library at Windsor Castle*. New York:
Johnson Reprint Corporation, 1998.
*A fairly small book, but the quality of the drawings
makes up for that.*

Stubbs, George. *The Anatomy of the Horse* (new edition).
Mineola: Dover Publications Inc., 1976.
*Stubbs was the top horse artist in eighteenth-century
England. His superb set of engravings of equine anatomy
remains a classic.*

Sutherland Boggs, Jean. *Degas at the Races*. Washington,
D.C.: National Gallery of Art, 1998.
*A marvelous coffee-table book about a great equestrian
artist of the late nineteenth century.*

Acknowledgments

I would like to thank everyone who has contributed to this book, in particular Sue and George for providing a unique workspace; Ann Hunt, MBE, for her wonderful equitation center at Easterton Farm, Perthshire; Charlie and Matthew Carrick for their superb Clydesdale horses; Perry Wood for creative inspiration; and Felicity George for her utter commitment to the well-being of horses. I would also like to thank all the dedicated members of the Society of Equestrian Artists for sharing their time and expertise, and Stewart Wright and the team at Doricmor Ltd. for their enthusiastic support.

Thanks also to Jake Spicer, from whom I have learned so much while writing and illustrating this book, to Oisin O'Malley, photographer, and to Zara Larcombe and Rachel Silverlight at Ilex Press. And of course thanks to all the horses—Pepper, Tom, Paddy, Tigger, Elvis, Ravel, Pavanne, and Ben, to mention just a few who have posed for me and inspired me.

Picture Credits

The illustration at the bottom of page 80 is based on an original drawing by Gottfried Bammes. I would like to thank Frank Calderon, whose *Animal Painting and Anatomy* provided a useful reference for several of my studies.